the art of HAIR

Rubi Jones

Photos **Agnes Thor**

Illustrations
Samantha Hahn

MAKEUP **KHELA**
WARDROBE STYLING **KAREN SCHAUPETER**

weldon**owen**

Contents

Introduction

I grew up around strong women who put equal emphasis on working hard and looking good while doing it.

Every time my extended family got together, somebody ended up with a new hairstyle: a perm, new fringe, a little bleach, or a simple braid. Aqua Net hairspray was our best friend, and my parents' kitchen was our beauty salon.

Since then, I've styled hair all over the world on photo shoots, backstage at fashion shows, at salons, and at pop-up workshops. But one of my favorite parts of my career is teaching women how to do their own hair. I feel the same energy, happiness, and confidence teaching a client how to perfect a braid or create glamorous waves as I did when we would gather around and do each other's hair in my parents' kitchen.

I love the empowerment new hair gives an individual—whether it's a bold cut or just switching up your part. The beauty of hair is that it can both transform and be transformed so easily. Curl it, straighten it, gel it, braid it, or pin it up—you can always wash it and change it again.

Included in this book are more than 40 step-by-step tutorials for creating on-trend and timeless hairstyles for everyday and special occasions. The diversity of my clients has taught me to appreciate and embrace each woman's unique hair texture, so you'll discover styles for a wide range of hair lengths and types. You'll also find all the tools and hair products that I believe every woman should stock in her own vanity, how they work, and how to use them properly—tips that are sure to help you become your own favorite stylist.

I hope you will use this book to master the perfect everyday blowout, find the perfect hairstyle for your best friend's wedding, style a playful look for a girls' night out, and finally replace your go-to messy ponytail for any one of my variations. I also hope that doing your own hair will help you feel more powerful and confident in your daily life. Don't forget to have fun!

Rubi a. Jones

Rubi's Rules FOR GOOD HAIR

It's just hair. So relax and have fun with it already.

All hair is different—the grass is always greener on the other side. Find out what works with your texture instead of fighting against it.

Finding a good hairstylist is like dating—invest the time finding the best person for you and your hair.

Get a cut every six to eight weeks; every ten to fourteen weeks if you're growing out your hair.

Invest in quality shampoo and conditioner (that means no drugstore brands!).

Products can be your best friend. Layer them into your hair at every styling step instead of using them to lacquer your hair into place at the end.

Use a tail comb to create clean sections, which will make styling easier.

When blow-drying, slow and steady wins the race—you'll get better results by gliding your brush and dryer through your hair slowly and consciously, focusing on your roots, then midlengths, and finally the ends, rather than a million times over through the entire length of your hair.

Squeaky clean isn't always the way to go—I usually recommend "perfectly dirty texture" for styling. Basically, that means washing every other day and using products to amp up your hair's texture and workability.

Backcombing creates great volume—and the perfect cushion for pins to grip on to. Insert your tail comb near the roots of a small section, then remove the comb and insert it slightly higher into the section. Continue to insert the comb higher and higher until the section is all teased.

Work your hair in the direction of your final style from the minute you start drying it. Go up for volume, back for ponytails or buns—you'll say good-bye to cowlicks and unwanted bumps because all your hair will know where it's going from the get-go!

Sometimes less is more. By all means, go for an edgy undercut, a crazy color, or an eye-catching braid. But sometimes just one standout element is enough.

Like anything, the more hair you do, the better you'll get at it. Some of the looks in this book are really simple, and then there are some that are more ambitious or time-consuming. Stick with it and you'll see results.

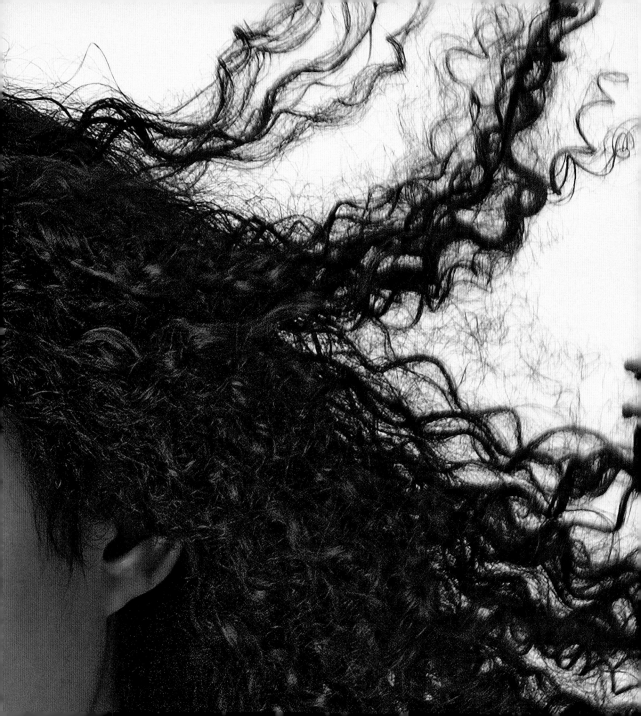

Basics

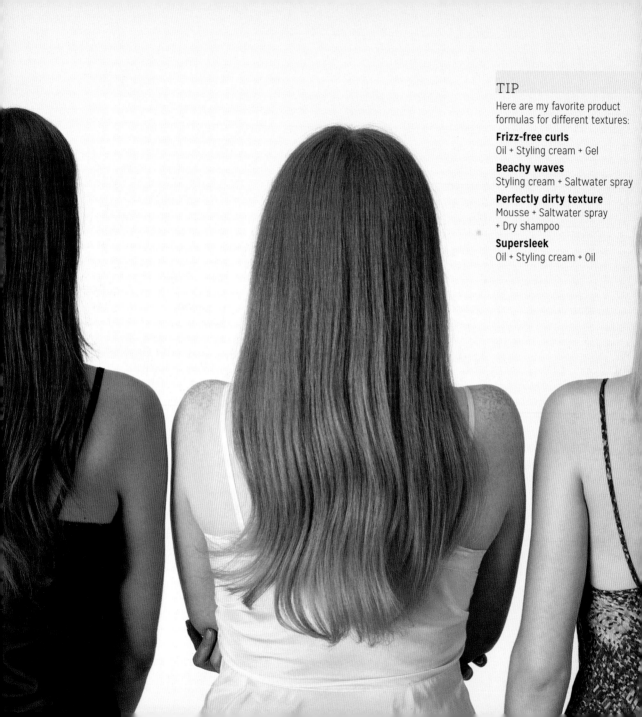

TIP

Here are my favorite product formulas for different textures:

Frizz-free curls
Oil + Styling cream + Gel

Beachy waves
Styling cream + Saltwater spray

Perfectly dirty texture
Mousse + Saltwater spray + Dry shampoo

Supersleek
Oil + Styling cream + Oil

HAIR
Product 101

You've seen all those bottles and canisters lined up at the salon. Here's a primer on what they all do—plus what you need and how to use it!

CLEAN IT

Shampoo Buy a salon-brand shampoo formulated for your hair type. Apply shampoo only to the roots and then massage it into your scalp—the shampoo will clean your ends when you rinse.

Conditioner Don't skimp on a salon-brand conditioner, even if you have oily tresses. Apply it only to your ends—your roots don't need it because they're the healthiest part of your hair. Rinse with cool water to seal in nutrients and shine.

Mask Use a deep conditioner once a month, especially if you have curly, dry, color-treated, or chemically treated hair. In fact, if you fall in one of those categories, you can replace your everyday conditioner with a mask for healthier hair on the daily.

Dry shampoo It comes in two basic formats: powder and aerosol spray. Apply on oily roots to extend your look for another day or throughout to give soft hair a workable texture for easier styling.

BUILD IT

Mousse Whether you want volume, curls, or a superstraight look, apply mousse to damp hair and blow-dry it in to create styles with staying power.

Volumizing spray Similar to a mousse (or any product with the word "volumizing" in its name), this spray helps create longer-lasting looks. Blow-dry it into damp hair, or layer it on with multiple applications between blowdries for extra volume.

Styling cream Used to add moisture and holding power, creams work on all types of tresses. A good rule of thumb: the thicker the cream, the thicker the hair it can go on. To apply, work it evenly into the hair at the back of your head (where your locks are thickest), then work a small amount onto the sides and top of your head.

Gel You can leave gel in for a sleek, wet look; blow-dry it in for extra hold; or diffuse it into your curls for frizz-free ringlets. Look for a non-flaky water-based gel to avoid those telltale white specks.

Saltwater spray Spritz on this lightweight and versatile spray for body before blowing out your hair, or use it to add texture to a finished look. You can also mist limp hair to encourage waves before air-drying or diffusing. I like to blow-dry it in roughly from roots to ends before styling—it creates a naturally dirty texture that makes styles last.

FINISH IT

Hairspray My favorite is lightweight and non-flaky. Layer it on—one blast before styling, one after your look is built—to avoid a crunchy look. For a high-shine, no-hair-out-of-place look, try an extra-hold spray. Bonus: It protects against heat, so blast your hair with it in sections before curling or ironing.

Oil and shine serum Use either on dry hair to add shine, or apply as a nourishing primer to damp hair before applying other styling products.

Wax and pomade Great for short hair and catching flyaways when braiding, pomades and waxes can vary from greasy to highly matte and extreme hold to none.

Edge cream Perfect for those stubborn baby hairs along your hairline. Apply a strong-hold one with your fingers and a small boar-bristle brush to set each hair into place. A little goes a long way.

Texturizing spray A perfect blend between hairspray and dry shampoo. Use this aerosol spray to add texture to curls, to build volume, and before braiding or styling into an updo.

Tools
OF THE TRADE

Don't fry! The finer your hair, the lower you should set the heat on your iron. Try 200–300°F (93–149°C).

FLAT IRON

A clamp gives you versatility in the type of curls you can create.

CURLING IRON

Blowdryer Splurge on a powerful, professional model that has at least 2,500 watts—more watts means speedier blowouts—and adjustable heat and airflow settings. In general, opt for high air and medium heat to prevent heat damage, and slowly move the dryer over your hair to avoid overdrying and to make each blast of air count.

Nozzle Your dryer will come equipped with a nozzle attachment, which you should always use unless you're after curls: It concentrates the airflow and prevents the dryer from blowing your hair every which way—thus minimizing frizz and speeding up drying time.

Diffuser A game-changer for curls, this add-on disperses airflow to create body and wave—without the frizz. For thicker hair, set your dryer to high air, medium heat when diffusing; for fine strands, opt for low heat. It's great for an air-dried look or to speed-dry gelled hairstyles.

Flat iron Look for adjustable heat settings and ceramic or titanium plates for even heat and shine. Maintain clean sections, and closely follow a brush or comb when ironing for the best results. Steam irons are another great alternative if you find yourself addicted to straight tresses.

Curling iron My favorite curling irons are gold-plated with adjustable heat settings. A 1-inch (25-mm) barrel works best for most styles, but in general, use large barrels for big waves and small ones for tighter spirals.

Curler set Steal your grandmother's hot rollers—plastic or Velcro are my favorite. Opt for non-heated rollers to lessen heat damage.

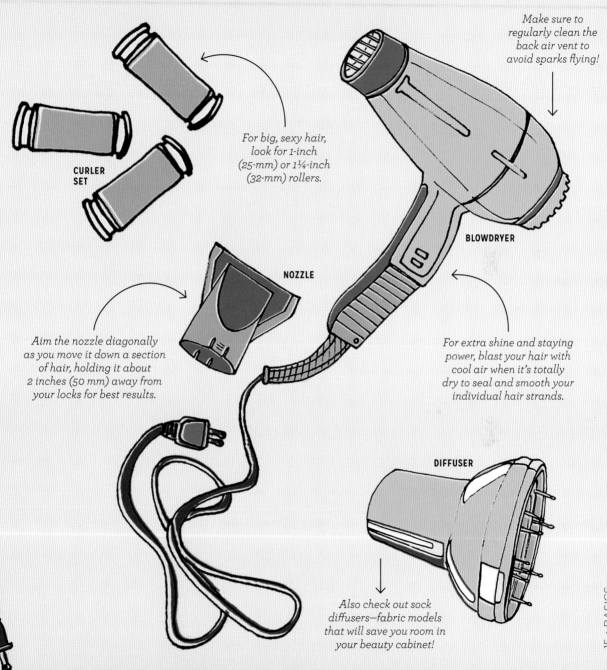

Make sure to regularly clean the back air vent to avoid sparks flying!

CURLER SET

For big, sexy hair, look for 1-inch (25-mm) or 1¼-inch (32-mm) rollers.

BLOWDRYER

NOZZLE

Aim the nozzle diagonally as you move it down a section of hair, holding it about 2 inches (50 mm) away from your locks for best results.

For extra shine and staying power, blast your hair with cool air when it's totally dry to seal and smooth your individual hair strands.

DIFFUSER

Also check out sock diffusers—fabric models that will save you room in your beauty cabinet!

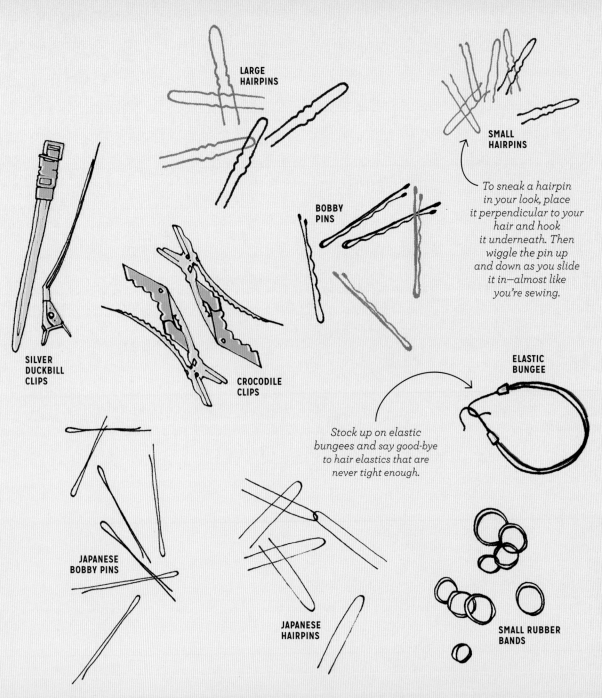

LARGE
HAIRPINS

SMALL
HAIRPINS

*To sneak a hairpin
in your look, place
it perpendicular to your
hair and hook
it underneath. Then
wiggle the pin up
and down as you slide
it in—almost like
you're sewing.*

BOBBY
PINS

SILVER
DUCKBILL
CLIPS

CROCODILE
CLIPS

ELASTIC
BUNGEE

*Stock up on elastic
bungees and say good-bye
to hair elastics that are
never tight enough.*

JAPANESE
BOBBY PINS

JAPANESE
HAIRPINS

SMALL RUBBER
BANDS

HOLD IT TOGETHER

Silver duckbill clip Secure sections of hair and use for curled sets. If you add tissue paper, you won't have to worry about creases in your style.

Crocodile clip These plastic, heavy-duty clamps can secure even the thickest section of hair while you're drying or styling other sections.

Elastic bungee To use, hook one end of the bungee onto your hair, then wrap the elastic around your ponytail. Hook the other end onto the elastic (not your hair!) to secure.

Small rubber bands Match your hair color and use to tie off braids or small ponytails.

Hairpins Large ones are great for anchoring a chignon or thick hair; small ones are fantastic for securing smaller sections or even whole looks. Hunt down ones that match your hair color.

Bobby pins These come in all colors and sizes. Choose stronger ones that return to their original shape after sliding into your hair.

Japanese hairpins You use them like normal hairpins, but their serrated edges grip and hold for long-lasting looks. Available mainly in black.

Japanese bobby pins You'll only need a few of these bad boys to secure your look. Great for thick, stubborn hair—or any time you don't want your hair to budge! Found in black or metallic.

BRUSH IT

Flat boar-bristle finishing brush Perfect your look with these soft bristles before a final douse of hairspray. Also good for light backcombing.

Round boar-bristle brush Great for smoothing out all hair types. When purchasing, look for long, close bristles: Your hair will glide easily through longer bristles, and tight bristles catch more hair.

Detangling brush or comb Use on wet or dry hair, or to lightly brush out curls.

Tail comb Use the metal end for clean partings and the close-knit comb part for backcombing.

Flat mixed-bristle brush The combination of bristles gives your hair a smooth, shiny "flat iron" finish without the extra heat.

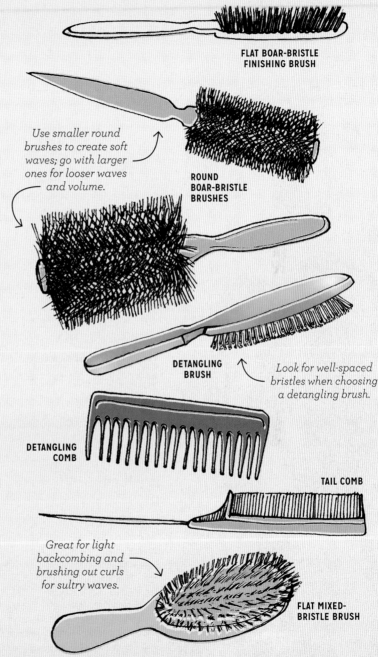

FLAT BOAR-BRISTLE FINISHING BRUSH

Use smaller round brushes to create soft waves; go with larger ones for looser waves and volume.

ROUND BOAR-BRISTLE BRUSHES

DETANGLING BRUSH

Look for well-spaced bristles when choosing a detangling brush.

DETANGLING COMB

TAIL COMB

Great for light backcombing and brushing out curls for sultry waves.

FLAT MIXED-BRISTLE BRUSH

17 • BASICS

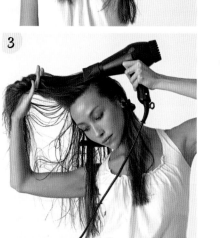

YOU'LL NEED
- **Desired products**
- **Two crocodile clips**
- **Blowdryer with nozzle**

OPTIONAL
- **Root lifter**
- **Shine serum**

GET A JUMP-START WITH A

Pre-Dry

To banish annoying cowlicks, make your locks fall nicely, and get your look started out right, always begin with a pre-dry: lifting and directing your damp hair from side to side with your hands as you blow-dry it.

1 Begin with towel-dried hair and work desired products into your hair from roots to the midlengths. (If you're doing a big look, apply more root lifter from roots to ends for added volume.) Add a few drops of shine serum to your ends if your hair is dry or color-treated, or if you want an especially glossy look.

2 Begin with a mohawk section of hair that spans from brow to brow and from your forehead to the nape of your neck. Hold the rest of your hair out of the way with crocodile clips.

3 Use your fingers to brush the mohawk section from side to side while lifting your roots straight off your scalp—this will prevent cowlicks and create volume. (Don't want volume? Just dry from side to side.) Direct the dryer so it follows your fingers as you rake them through your hair, focusing mainly on your roots.

4 Once the roots of your mohawk section are dry, repeat with the hair on the sides of your head. Use your fingers to brush your hair forward then backward, which will make your hair fall nicely around your face (instead of forming strange peaks along your hairline).

5 All your hair should feel about 80 percent dry at this point. Now style it however you like—check out the tutorials on the next few pages for ideas.

Frizz-Free
BLOWOUT

Get the sleekest, straightest tresses around. The trick is lingering on the ends to seal in the silkiness.

1 Start with towel-dried hair and apply styling cream from roots to ends, then serum from midlengths to ends. Pre-dry until your roots are 80 percent dry. (If your hair is very curly, skip the pre-dry.)

2 Divide a section from ear to ear, then keep the hair above your ears out of the way with a crocodile clip. Split the section below in half.

3 Set your blowdryer to high air and medium heat. While sandwiching one section of hair taut between your thumb and a downward-facing flat mixed-bristle brush, blow-dry downward while maintaining tension. If your hair is really frizzy, thick, or curly, blow under your section, too—just blast it one more time from the top to correct flyaways and frizz.

4 Once your roots are dry, hold the mixed-bristle brush under the section and slowly brush from roots to ends, following the brush diagonally with the dryer.

5 Seal the ends by keeping the dryer on them for a few extra seconds—this will prevent flyaways and a dry, split look. (Linger over the ends of any layers, too.)

6 Repeat on the next section, then take down the clipped hair, make new sections equal in size to the first sections, and repeat until all your hair is straight.

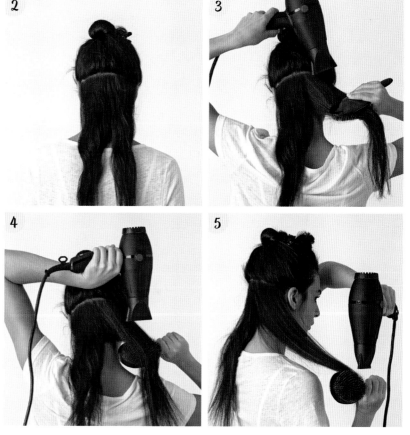

YOU'LL NEED
- **Desired products**
- **Three crocodile clips**
- **Blowdryer with nozzle**
- **Flat mixed-bristle brush**

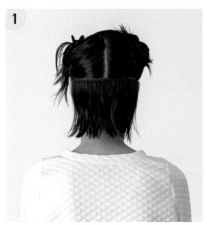

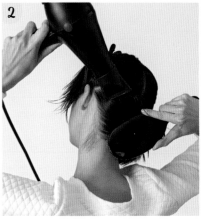

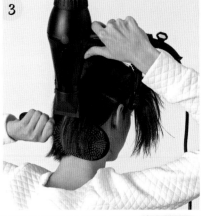

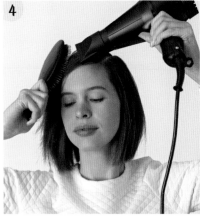

Wrap-Dry YOUR BOB

For a shiny, perfectly shaped bob every time, pretend the curve of your head is a giant round brush, then direct and dry your hair around it.

1 Towel-dry your hair and apply any desired products. Then make four sections: one below your ears, one on either side of your head from the back section all the way to the front hairline, and one mohawk from your front hairline to your crown. Secure all but the section below your ears with a crocodile clip.

2 Set your blowdryer to high air and medium heat, then blow-dry the back section by brushing your hair from one side to the other, "wrapping" it against your head as you follow the flat mixed-bristle brush with your blowdryer. Move the nozzle diagonally and slowly, catching all the hair and creating a smooth foundation for other sections to fall on.

3 Once the section is 80 percent dry, place the brush under it and blow-dry from midlengths to ends. Move your brush slowly, and keep the dryer close to the hair without touching the brush. Repeat steps 2 and 3 on the two side sections.

4 Wrap-dry the mohawk section last. Find your desired part, then place the brush under the top section and blow-dry it from midlengths to ends.

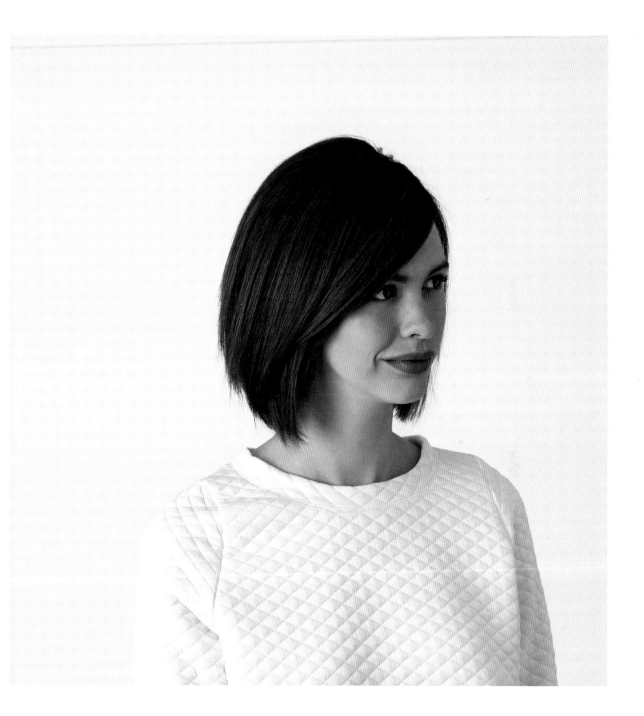

TIP

To roll your hair around a round brush without pesky (and painful) tangles, make sure you have cleanly defined sections that are no wider than your brush.

2

YOU'LL NEED
- Mousse
- Shine serum
- Root lifter
- Blowdryer with nozzle
- Crocodile clip
- Small or medium round boar-bristle brush

TWIRL A ROUND
BRUSH FOR LONG,

Smooth Waves

You know you want them: long, gently cascading, glossy tresses that look like they took no effort at all. Discover a few secrets of the round brush and easy is what they'll be.

1 Start with damp hair and apply mousse from roots to ends and shine serum from midlengths to ends. Apply a root lifter on your roots for extra volume, then pre-dry until your roots are 80 percent dry.

2 Divide a section from ear to ear at the back of your head. Secure the hair above your ears with a crocodile clip and split the hair below your ears into two.

3 Set your dryer to high air and medium heat. Brush your hair over the top of one section with your round boar-bristle brush, with your thumb underneath to maintain tension, and blow-dry your roots.

4 Place your round brush under the section and follow it with your dryer from roots to ends, then wrap your hair around it and follow the brush with the dryer as you roll the brush up and down the hair. Roll down halfway and then up to your roots a few times to mold the wave and dry the midlengths and ends. Avoid tugging on the hair.

5 When your section is dry, roll it down once more, then gently hold it while you twist the brush to release the hair. Repeat on the other section. Then take down the clipped hair, create equal-size sections in a new row, and repeat until smoothly curled locks are all yours.

3

4

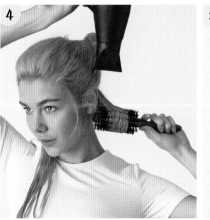

5

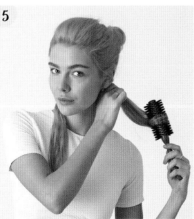

25 • BASICS

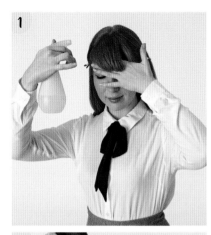

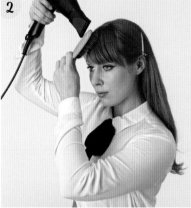

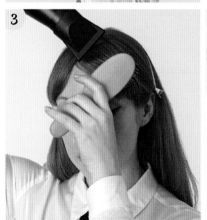

YOU'LL NEED
- Silver duckbill clips
- Spray bottle filled with water
- Blowdryer with nozzle
- Flat mixed-bristle brush

ESSENTIAL

Bangs Blowout

Here's how to have perfect bangs on the daily. For a side-swept variation of this straight up-and-down look, angle the brush diagonally against your forehead in the final step and direct your hair to the side.

1 Once your bangs dry, there's no changing them, so tackle them first when styling your hair. Start by using silver duckbill clips to hold the rest of your hair out of the way. Then spray your bangs down with water, focusing on your roots to get rid of cowlicks.

2 Turn your dryer on high air and medium heat, and place your flat mixed-bristle brush on top of one side of your bangs. Aim your blowdryer's nozzle right behind your brush so it points slightly down and on the diagonal.

3 Now that your tools are in position, brush and blow-dry your bangs to one side. Try not to brush all your bangs in one swoop—do it in smaller sections so you can get all your roots going in one direction. Repeat these steps by drying to the other side until your roots are dry.

4 Place the back of your brush flat against your forehead and lay your bangs over the bristles, then blow-dry straight down with the air flowing over the middle of the brush. Don't stop until you've reached the very ends to achieve perfect, face-framing bangs.

YOU'LL NEED
- Oil
- Moisturizing styling cream
- Gel
- Blowdryer with diffuser

OPTIONAL
- Saltwater spray

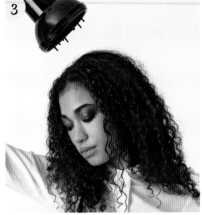

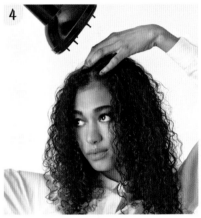

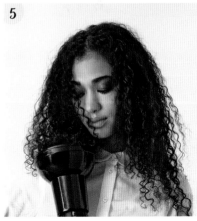

Diffuse
FOR NATURAL CURLS

A diffuser is your go-to attachment for coaxing out springy, bouncy, and frizzless curls every time.

1 Apply your favorite curly-hair concoction on wet hair. No two curls are alike, but all can use a little moisture, so I layer oil, moisturizing styling cream (a lightweight one for fine hair and a heavier one for coarse), and gel. For straight hair, replace gel with saltwater spray.

2 Allow your hair to fall normally and use your fingers to create a part, if you like. Then wrap your natural, individual curls around your index finger to add definition. You can do this all over your entire head or just at your crown and hairline.

3 Attach a diffuser to your blowdryer—this will mellow out the airflow and prevent frizz. Point your dryer diagonally down on your head and avoid touching your curls while drying at first—you risk frizz and big hair. Hold for 30 seconds, then dry the rest of the top of your head.

4 Now point the dryer at the side of your head. Resist the urge to angle up; if anything, angle down a little. Again, don't touch your hair yet. Do this for about 30 seconds on all sides of your head. Once your hair is about 40 percent dry, pinch and lightly lift the hair at your crown while diffusing for natural volume.

5 Once your hair is 80 percent dry, let it air-dry the rest of the way, or continue diffusing while touching your hair. For more spring, point the diffuser up from below your curls while tilting your head to the side or back.

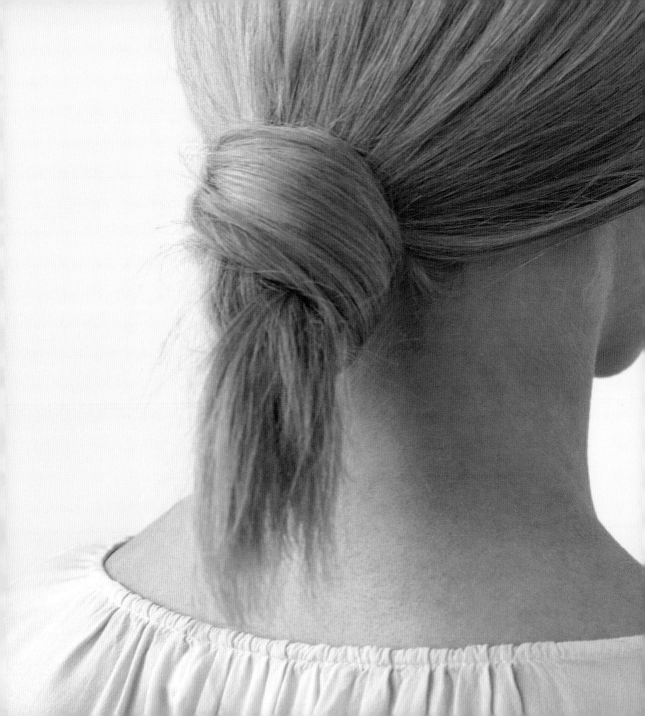

Ponytails

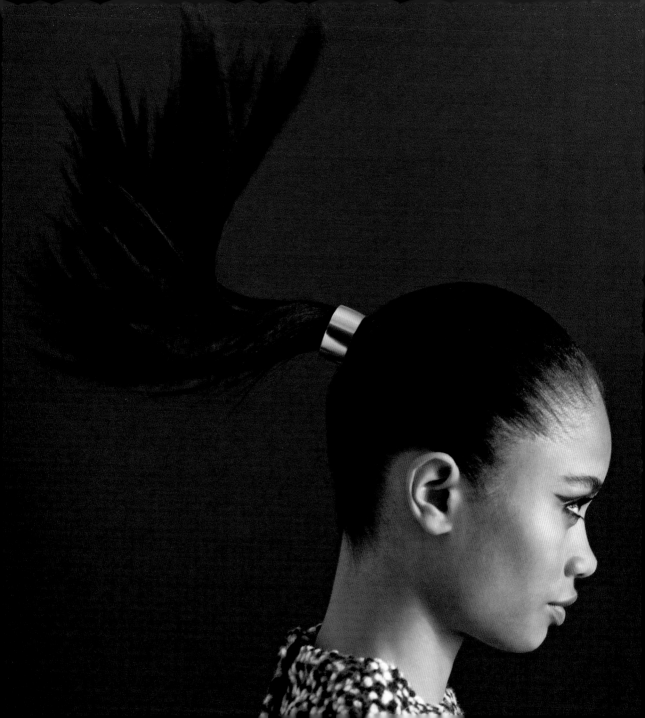

THE ART OF THE

Ponytail

Nothing beats the casual elegance of a perfect ponytail—plus, it makes a great base for more ambitious looks. Follow these tips to step it up from that lazy gym-class one you used to wear!

YOU'LL NEED
- **Light-hold styling cream**
- **Blowdryer with nozzle**
- **Flat mixed-bristle brush**
- **Elastic bungee**
- **Hairspray**

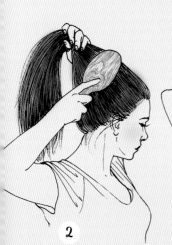

1 Apply a quarter-size amount of light-hold styling cream from roots to ends. Blow-dry the product into your hair while directing your hair toward the back of your head with a flat mixed-bristle brush.

2 Gather your hair on your head where you'd like your ponytail and hold it about 1 inch (25 mm) away from your scalp. For a smooth pony without those annoying bumps, brush your hair into your hand with your flat mixed-bristle brush before tightening your grip against your scalp. (Stand up straight, too, so it doesn't droop or sag at the bottom!)

3 Without letting go of your hair, use your other hand to encircle the ponytail with the area between your thumb and index finger. For a snug fit, sweep your hand from your nape to where your ponytail sits, applying pressure with the inside of your hand to smooth the hair at the back of your head as you go.

4 To secure your ponytail, hook one end of an elastic bungee into your hair, then wrap the elastic around the ponytail's base and hook the end around the elastic. Hit the whole look with hairspray to keep flyaways in check.

33 • PONYTAILS

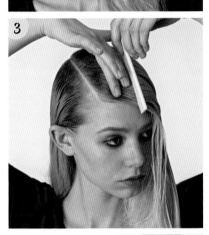

YOU'LL NEED
- Blowdryer with nozzle
- Tail comb
- Gel
- Tissue paper
- Two silver duckbill clips
- Elastic bungee
- Flat iron
- Shine serum
- Hairspray
OPTIONAL
- Diffuser

SLEEK PONYTAIL WITH

High-Shine Fingerwaves

Keep it subtle and minimalist with graceful fingerwaves and a low-profile ponytail. This look needs a lot of gel—don't be afraid to use it!

1 Blow-dry your hair so it's straight and smooth. (If your hair is curly, blow it straight and then flat-iron it.)

2 To create a deep side part, hold your tail comb at the arch of your eyebrow, then pull it straight back to your crown.

3 Comb gel through the smaller section of hair on one side of your part, then on the larger section, bringing this section slightly forward—about 1 inch (25 mm) past your hairline. (If your hair is so curly that it kinks when you use gel, skip the gel and go with hairspray and shine serum instead.)

4 Starting at the part, comb your hair forward past your front hairline. Then, without lifting the comb, direct the hair back toward the hairline, using your other hand to form a smooth, continuous curve.

5

TIP

What's with the tissue paper, you might be asking? It keeps the duckbill clips from pressing into your hair and creating unsightly creases in your fingerwaves while they dry.

5 Repeat, firmly keeping the curve in place with one hand while you create another curve below the first. Don't press down too hard with your comb; otherwise, you might undo the first curve. Keep making waves—when you reach your ear, you should have a continuous S shape across your forehead. (If the gel starts to dry up, lightly mist it with hairspray as needed.)

6 Fold pieces of tissue paper into narrow strips and place them on top of each fingerwave, then secure each with a silver duckbill clip. This will ensure that the waves don't move while the gel dries and you create your ponytail.

7 Pull the rest of your hair back into a very low ponytail. Use your comb to make it sleek and clean, then secure it with an elastic bungee: Hook one end to your hair, wrap the elastic around the ponytail, and then hook the other end to the elastic.

8 Flat-iron your ponytail so it's stick straight. Apply a little shine serum to make the hair really gleam.

9 Once the gel has dried, remove the clips and tissue from your fingerwaves. (You can speed up the drying process by diffusing them for a few minutes). Hairspray the whole thing and you're ready to shine all night.

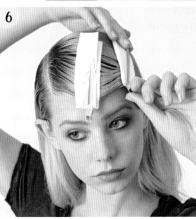

6

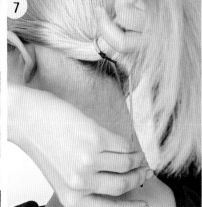

7

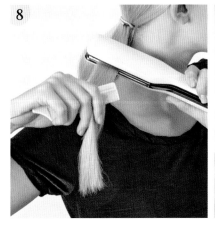

8

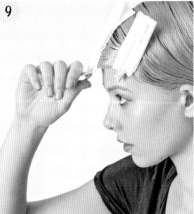

9

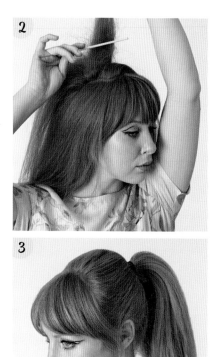

Fresh + Preppy
PONYTAIL

Channel Betty from *Archie Comics* with this cheerful ponytail—my favorite part is the exaggerated curl. Top it off with a ribbon for a little extra bounce.

1 Start with clean, dry hair. Spray root lifter on your crown and blow-dry it into your locks for volume.

2 Using your tail comb, backcomb the roots on top of your head, focusing mainly on the crown. Smooth your hair with a flat mixed-bristle brush, taking care not to brush out the backcombing.

3 For perfect placement, imagine a diagonal line back from the top of your ear and gather your ponytail where the line ends. Hook an elastic bungee to your hair, wrap it around your ponytail, and then hook the other end to the elastic.

4 Divide your ponytail into two or three sections and hairspray each, then curl them individually with a 1-inch (25-mm) curling iron. Wrap each in the same direction around the iron from midlengths to ends, then hold for several seconds.

5 Let each section cool, then brush them together into a perfectly blended ponytail. Rotate your wrist at the bottom to really shape your curl. Hit it with hairspray.

6 Tie a ribbon around the base of your single, bouncy curl.

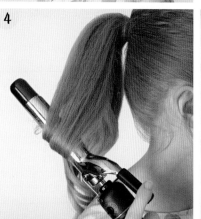

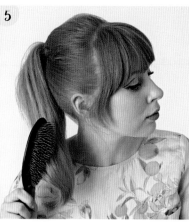

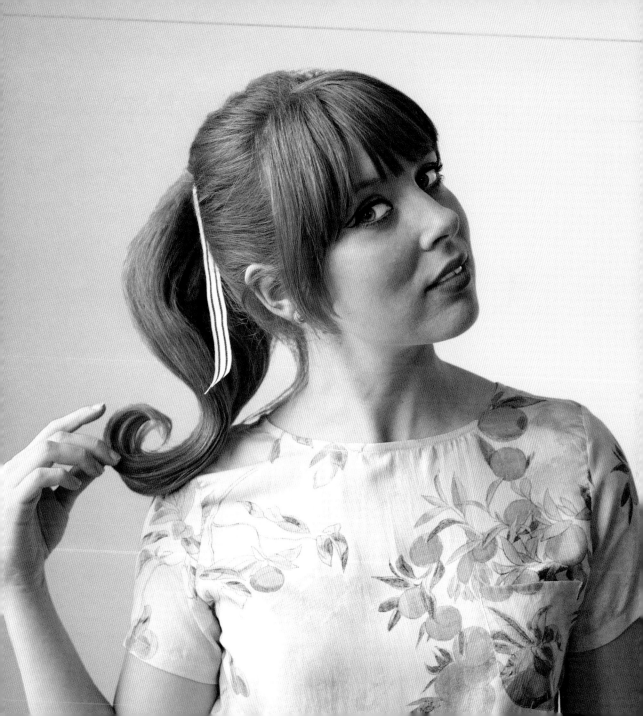

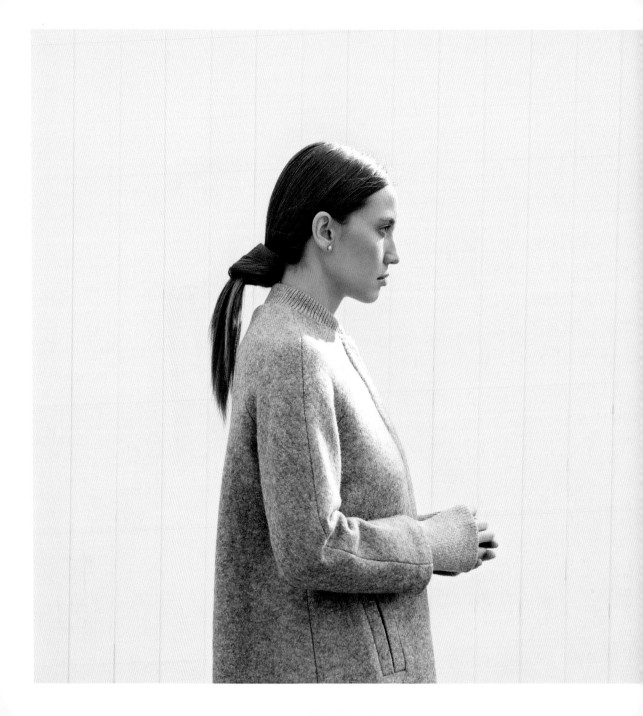

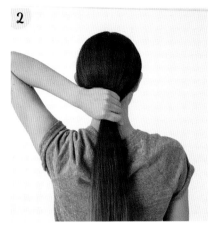

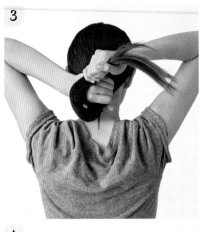

KNOT UP A
Tomboy Ponytail

Break out the Boy Scouts manual and dust off those rope-tying skills! This overhanded style may look tricky—but it's really just a basic knot.

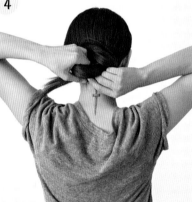

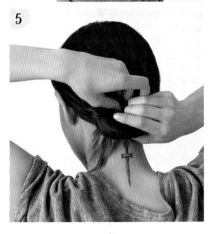

1 Use a tail comb to make a middle part in clean, damp hair. Spray root lifter from roots to ends and blow-dry it in, combing with your fingers. (Smooth any wavy or curly locks with a flat mixed-bristle brush.) Once dry, reapply root lifter from your nape to the ends and blow-dry again.

2 Gather all your hair into a low ponytail and hold it with your nondominant hand—

your thumb and index finger should be on the bottom.

3 To create a loop with the ponytail, grab its ends with your dominant hand and bring them up and over your other hand.

4 Pull the ends down around the bottom of the loop and then begin pushing the ends up into the loop's center.

5 Pull the ends through the center, bringing them up and out of the top of the loop. Keep the loop as close to your scalp as possible. (If your hair won't hold the knot, undo it, spray your locks with dry shampoo, and give it another go.)

6 Slide small Japanese hairpins into the knot from both sides to hold it in place.

FASTEN YOUR PONYTAIL WITH A

Peekaboo Fishtail

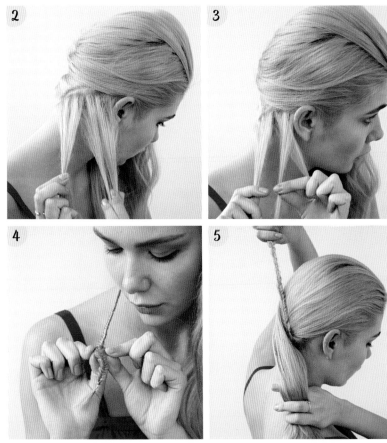

Skip the elastic! Secure this low style with a tiny, textured braid instead.

1 Apply dry shampoo to dry hair and gather it all going back and away from your face.

2 Take a long skinny section that runs along your hairline from behind your ear to the nape of your neck. Divide this section into two parts to start a fishtail.

3 Bring a strand of hair from the far side of one section across the gap between your two sections, then merge It with the second section. (See page 90 for full fishtail instructions.)

4 Repeat, alternating strands from both sections, until you've reached the ends of your hair. Secure with a small rubber band, then loosen the braid a bit by pulling it from both sides, starting from the bottom. This will make the braid wider, looser, softer in texture, and more eye-catching.

5 Pull the rest of your hair into a low ponytail, leaving the braid out. Wrap the fishtail around the ponytail several times. Then pin it in place with one or two strong bobby pins.

TIP

To give your hair a little more oomph, try misting saltwater spray on the ends and gently tousling it for texture.

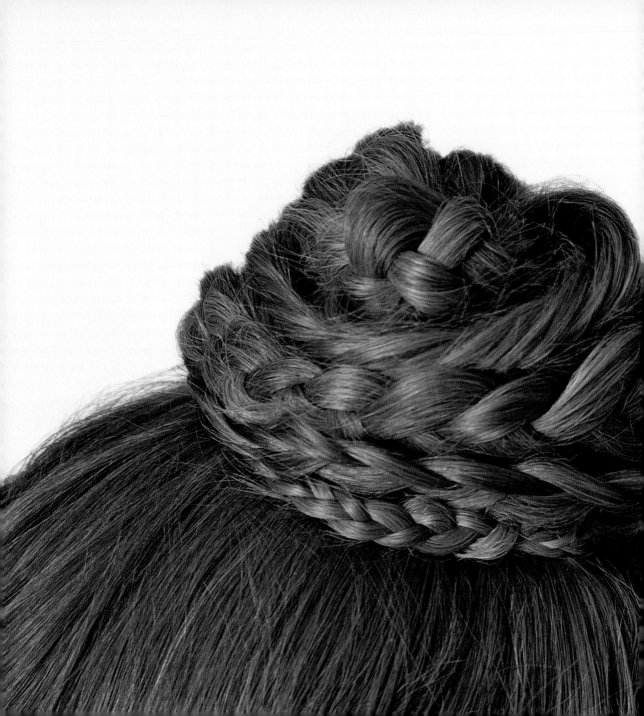

Buns
+
Chignons

THE ART OF THE *Bun*

Borrow from ballerinas with a chic, versatile, and high bun. Once you've added this basic to your repertoire, you'll discover endless variations. No donut bun required!

YOU'LL NEED
- Flat mixed-bristle brush
- Elastic bungee
- Hairspray
- Flat boar-bristle finishing brush
- Large hairpins

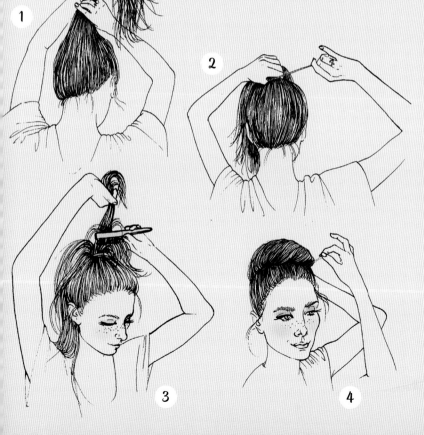

1 Smooth your hair with a flat mixed-bristle brush, then gather a ponytail high on top of your head. (See page 33 for more ponytail tips.)

2 Secure the ponytail in place by hooking one end of an elastic bungee to your hair, wrapping the elastic around the ponytail, and hooking the other end around the elastic. Blast it with hairspray.

3 Allow the hair from your ponytail to evenly fan all the way around the base so there's a little pit in the middle. Work your way around the bun, lifting the hair in sections and using a flat boar-bristle finishing brush to lightly backcomb its underside to create nice, billowy volume. Just be sure to keep the backcombing on the underside of the hair—this way, it will be hidden inside the bun, leaving the surface relatively smooth.

4 Carefully wrap your hair around the ponytail's base, preserving the fan effect on top and tucking the ends under the bun itself. Do this gently so the bun's exterior layer remains smooth and stays the size you'd intended. Now, imagine four corners around your bun and secure it in place with hairpins at each spot.

47 • BUNS + CHIGNONS

YOU'LL NEED
• Elastic bungee
• Small hairpins
• Bobby pins
• Hairspray
OPTIONAL
• Tail comb

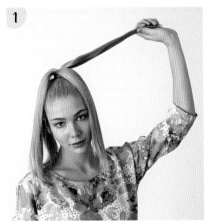

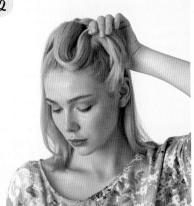

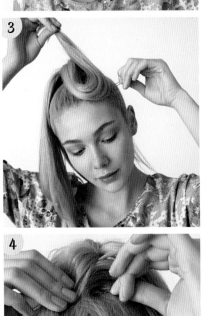

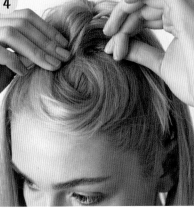

THE LOVELY
Loops Updo

I love a good bun as much as the next girl, but sometimes a classic needs a good dose of intrigue! This look calls for piling sections of hair in artful arrangements on top of your head, creating dimension and surprise.

1 Start with clean or one-day dirty hair. Gather your locks at the top of your head and secure them with an elastic bungee, then split the ponytail into three or four sections. (If your hair is fine, lightly tease each one with a tail comb to plump it up.)

2 Hold one of the sections up and lay half of it down on your crown so it naturally folds into a cute loop.

3 Pin it at the loop's folded center, weaving a small hairpin under the hair to conceal it. Try to hide all the pins!

4 Loop the section's loose end toward your ponytail's base and pin again. Leave the ends out for texture or cover them with the next section for a cleaner look.

5 Repeat, arranging all the sections in graceful piles—try intertwining a few for a woven feel. Secure with bobby pins and seal with a dash of hairspray.

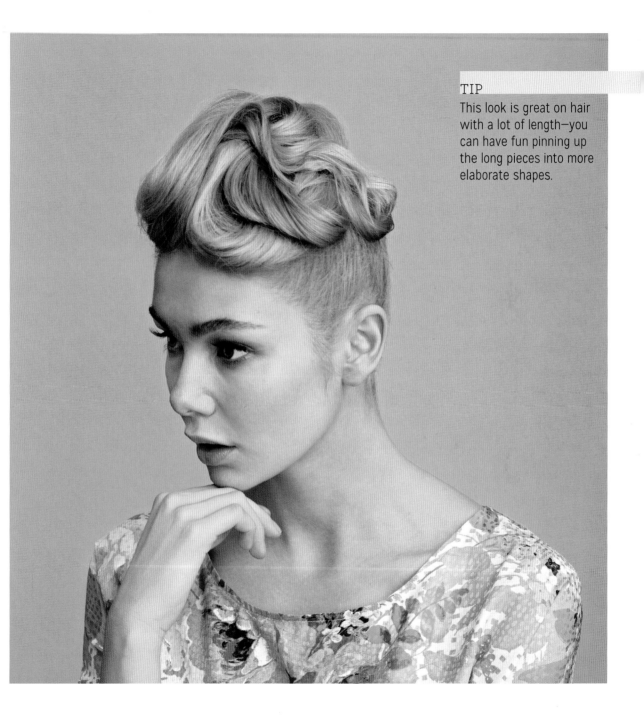

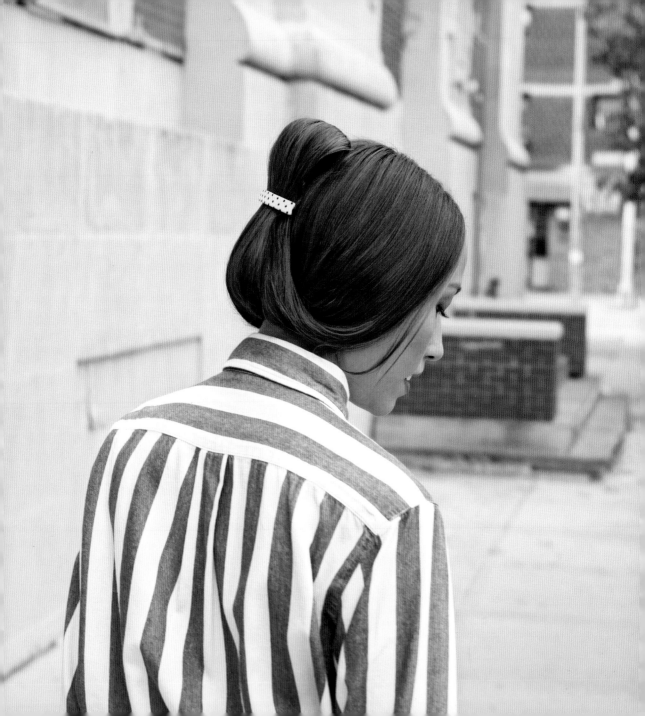

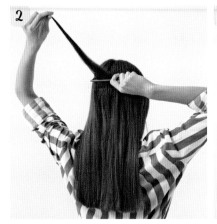

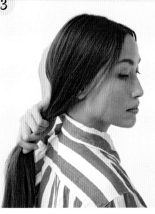

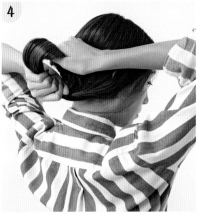

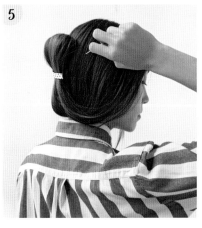

QUIRKY
Annie Hall Bun

Diane Keaton famously made menswear romantic, "neat" a buzzword again, and easy buns the most sophisticated style around.

1 Start with clean, dry, and straight hair. Use your tail comb to create a clean middle part from your front hairline to the crown of your head. Lightly spritz your hair with hairspray, then smooth it with a flat boar-bristle finishing brush.

2 Take a 1-by-2-inch (25-by-50-mm) section of hair in the middle back of your head and tease it using your tail comb. This is to create a little cushion to pin your barrette to later. Smooth your hair over the backcombing when you're done.

3 Loosely gather all your hair about 3 inches (75 mm) away from the nape of your neck, as if you were going to make a low, loose ponytail. Pull out some wisps of hair around your front hairline.

4 Fold the ponytail up toward the back of your head, creating a loop. Tuck the ends into the bottom of the loop—this will prevent the bun from falling apart later.

5 While holding onto your loop, secure the hair to the backcombed section with a long barrette. A couple of Japanese bobby pins will help hold it all in place.

6 Seal the look with another light mist of hairspray and you're ready for business.

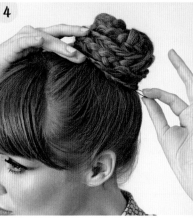

YOU'LL NEED
- Flat mixed-bristle brush
- Elastic bungee
- Several small rubber bands
- Small hairpins

STACK BRAIDS INTO A

Stylish Topknot

Give the tried-and-true high bun new life by piling it up with braids of varying textures.

1 Start by brushing your hair with a flat mixed-bristle brush into a high ponytail at the back of your head, then fasten it with an elastic bungee. Separate out about one-sixth of your ponytail and braid it until you reach the ends. Finish it off with a small rubber band.

2 Grab another section of hair and start a new braid—this time, up the variety and texture by making it a fishtail. To do so, divide the hair into two sections and pass a sliver of hair from the far side of one section to the other, dropping the sliver so it merges with the second section. Keep passing small slivers back and forth between the sections until you run out of hair. (See page 90 for more fishtail tricks.) Finish this braid off with a small rubber band, too.

3 Keep going until your ponytail is a bunch of different braids. Grab each one from the sides and tug outward to widen them a little. This will bulk them up and give them a soft, touchable texture so they don't look so squeaky clean. (Of course, if you're going for a really tidy look, skip this step.)

4 Wrap the braids around your ponytail and stash the ends, securing them under the bun with small hairpins.

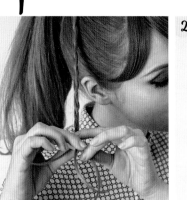

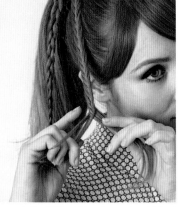

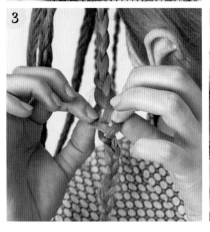

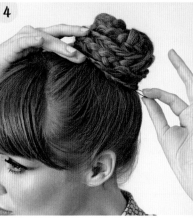

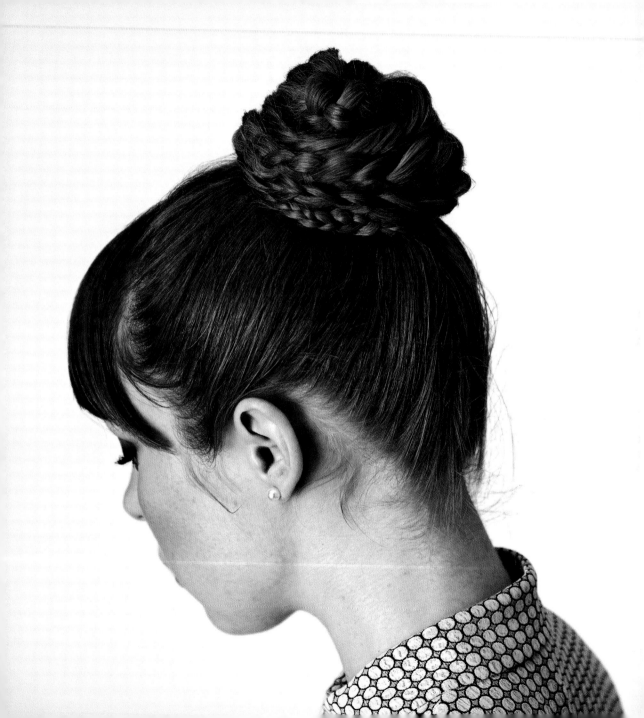

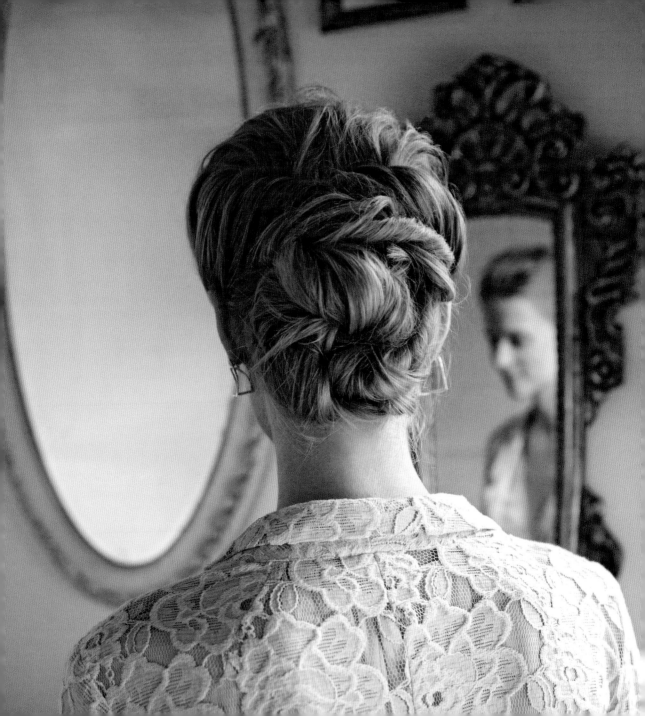

YOU'LL NEED
- Mousse
- Saltwater spray
- Blowdryer with diffuser
- 1-inch (25-mm) curling iron
- Tail comb
- Large hairpins
- Small hairpins
- Hairspray

TURN HEADS IN AN
Elegant Updo

Ace this wedding season with an effortlessly chic hairstyle—whether you're the bride, a bridesmaid, or the mother of the bride. Add a little sparkle or a touch of gold and you're ready to go.

1 Liberally apply mousse evenly from roots to ends, then spritz saltwater spray in sections from roots to ends as well. Blow-dry your hair with the diffuser attachment, directing it back from your face and using your fingers to encourage waves. When your hair is 80 percent dry, mist saltwater spray all over it again and continue drying.

2 When your hair is completely dry, add some loose curls with a 1-inch (25-mm) curling iron. These curls are simply meant for movement and texture, so just get the iron in there and don't overthink them!

3 Section out the hair along your top front hairline and backcomb it with a tail comb to create volume. (If you have bangs, tease the hair right behind them backward, then blend your bangs in with the backcombed hair.)

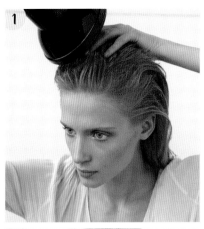

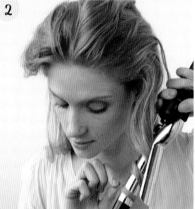

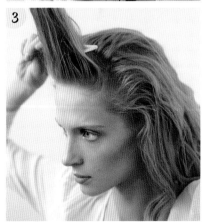

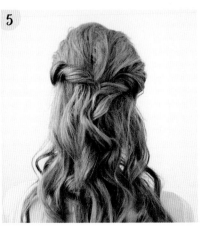

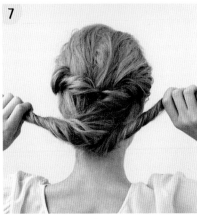

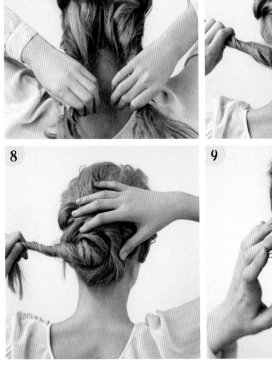

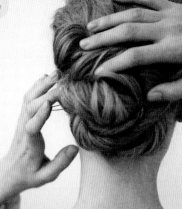

4 Gather the hair above your ear and below your front hairline on one side, then twist it toward the middle back of your head.

5 Repeat on the other side and loosely secure the twists at the back and along the sides of your head with small hairpins. Keep it relaxed—you don't want to mess up the texture you just created.

6 Split your hair into two sections at the middle back of your head. Holding one section in each hand, twist them inward until you reach the ends.

7 Cross the twists at the nape of your neck while bringing the coils up toward your crown.

8 Wrap one twist around the base of the other twist until you run out of hair, keeping the bun below the two side twists you pinned in place in step 5. Secure the bun with large hairpins.

9 Repeat with the second twist, encircling the first coiled loop. Use small hairpins to secure all those tendrils in place. If it feels loose, weave a few large hairpins in as well. Make sure it isn't too tight—this style looks best with a little bit of loose volume and soft, romantic texture. Hit it with hairspray so it lasts.

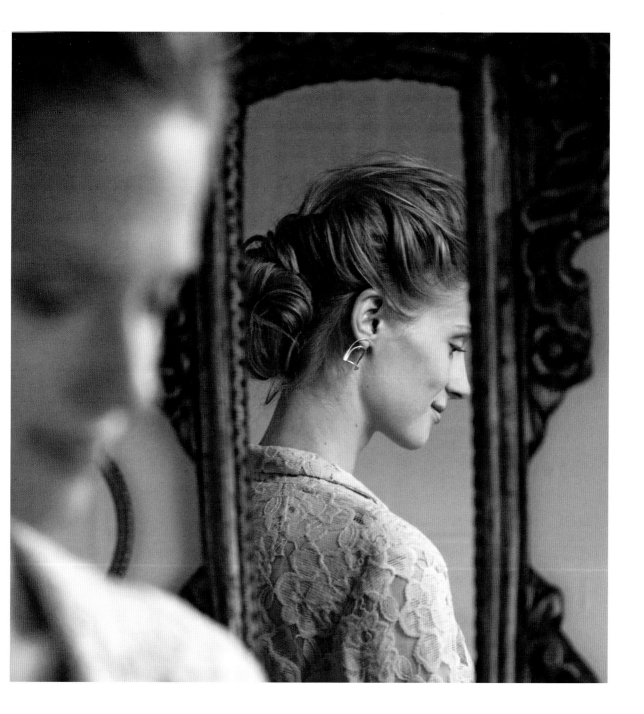

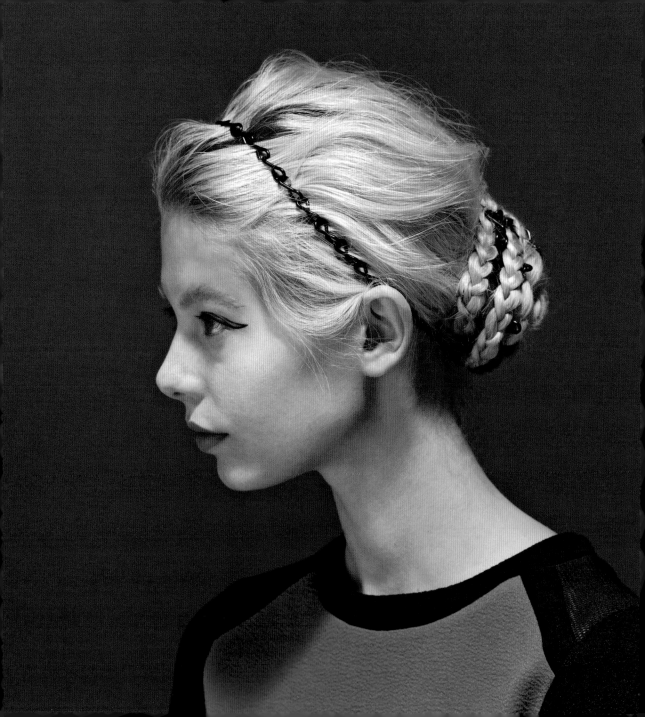

2

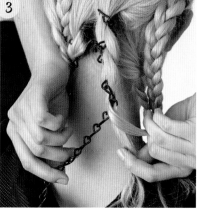

3

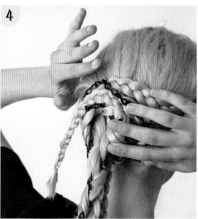

4

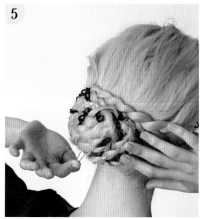

5

YOU'LL NEED
- Dry shampoo
- ¾-inch (19-mm) curling iron
- Crocodile clip
- Thin chain that's twice as long as your hair
- Small hairpins

BRAID CHAIN INTO A

Hip Chignon

I grew up going to the hardware store with my dad, so it was inevitable that one day I'd start incorporating tools into beauty. Here I swapped ribbon for a metal chain—the result is edgy but still graceful.

1 Liberally apply dry shampoo from roots to ends. Then use a ¾-inch (19-mm) curling iron to loosely curl your hair in random sections, making sure to curl the hair at your hairline away from your face. Lightly pull the curls while they're still warm—this way, you'll avoid ringlets and have perfectly disheveled waves instead.

2 Gather your hair out of the way with a crocodile clip. Create a headband with the chain by wrapping it around your head and tying it at the nape of your neck, leaving two equal lengths hanging from the knot. Insert small hairpins through the chain to secure it to your hair.

3 Take down your hair and divide it into three to five sections. Braid each one, but in two of the braids, replace a section with one of the lengths of chain and weave it throughout the braid.

4 To make a base for the chignon, wrap one braid into a flat bun and secure it with small hairpins. Pile a few braids on top, winding them around the base and pinning as you go.

5 Add the rest of the braids, wrapping, layering, and pinning them into a chignon. Tuck in the ends and insert hairpins around the chignon's perimeter.

59 • BUNS + CHIGNONS

SKY-HIGH
'60s Beehive

I always see ladies wearing these huge half-up, half-down beehives in photos from the 1960s—I get the Ronettes' "Be My Baby" stuck in my head just looking at them! Here's how to rock one.

1 Spray dry shampoo all over dry hair, then hit it evenly with hairspray.

2 Use a tail comb to create an arch at the back of your head extending from ear to ear. Then form a triangle of hair that stretches from the end of one brow to your ear; secure it with a silver duckbill clip. Repeat on the other side, then clip the rest of your hair out of the way.

3 Secure the arch-shape section with a silver duckbill clip, then tease the hair from the arch to your front hairline. Full disclosure: This will take time. Starting from the part, backcomb 1-inch (25-mm) sections from roots to ends. Keep going forward until you reach your front hairline, sweeping the backcombing away from your face to create height and roundness.

4 Secure the teased hair with silver duckbill clips and then backcomb the triangle section on your right side.

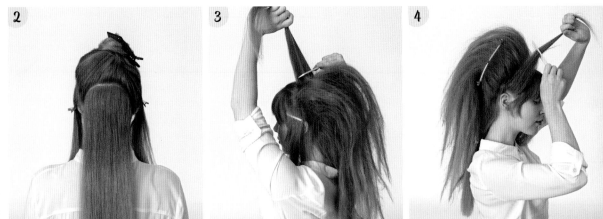

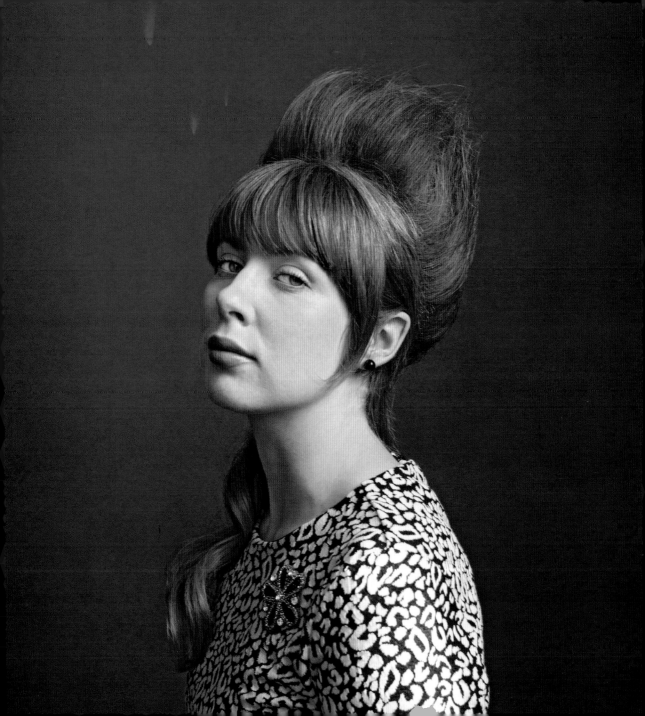

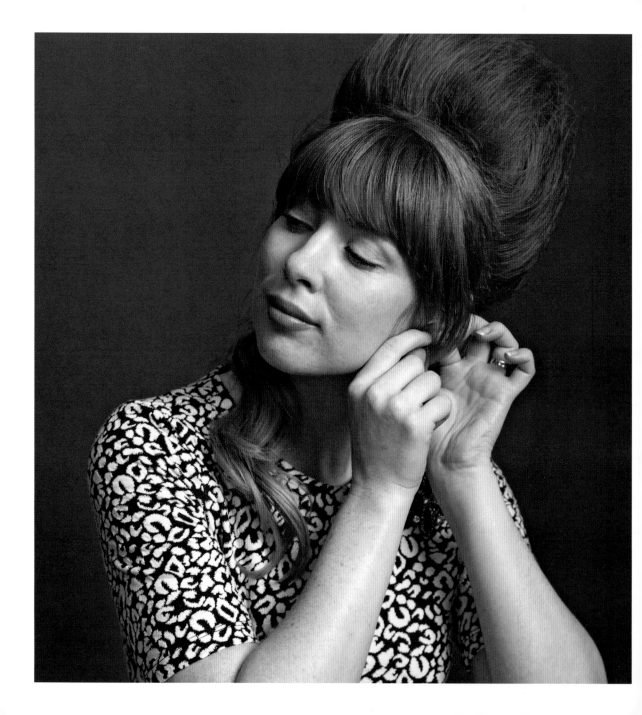

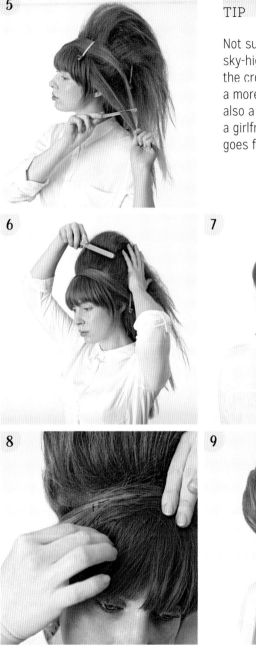

5 Wrap the right triangular section around the front of your head like a headband and secure it in place with a silver duckbill clip—if you have especially long hair, it might extend past your ear. (If you have bangs, position the headband section behind them but in front of your backcombing.) Then backcomb the roots of the left side section and clip both side sections together.

6 Use a flat boar-bristle finishing brush to smooth out the top of your beehive and the top of the headband.

7 Wrap the left side section around the back of your head and then overlap it with the right section—now the headband—at the front of your head.

8 Use hairspray to glue the overlapping front sections together, and weave small hairpins or bobby pins to keep them in place. Add a few pins along the back for additional security, then blast the beehive once more with hairspray.

9 Now use a ¾-inch (19-mm) or 1-inch (25-mm) curling iron to loosely curl the U-shape section below the bouffant and bring it over one shoulder. Your beehive is now dance-floor ready.

Not sure you want to go sky-high? Backcomb only the crown of your head for a more tame look. This is also a great style to do with a girlfriend so the teasing goes faster.

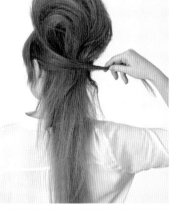

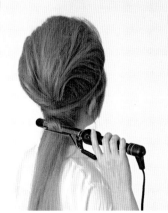

YOU'LL NEED
- Pomade
- Tail comb
- Three crocodile clips
- Three small rubber bands
- Small hairpins

DAYDREAM AWAY WITH A

Romantic Chignon

1 Rub a dime-size amount of pomade between your hands to keep stray strands from sticking out of your braids. Rub more on your hands as needed.

2 Using a tail comb, divide your hair into three sections: two on either side of a center part at the top of your head and one for all the hair behind your ears. Hold each section in place with a crocodile clip.

3 Starting near your part, pick up three tiny sections from your hairline and begin a Dutch braid, crossing the outside sections under the middle one and picking up loose hair from either side of the braid as you go. (See pages 74, 77, and 97 for more Dutch braid instructions.)

4 Continue Dutch-braiding, moving your hands toward the back of your head and working close to your scalp. When you can't add more hair, switch to a classic three-strand braid and finish with a small rubber band. Repeat on the other side.

Dutch braids get knotted up in an intricate, feminine updo across the back of your head. Classic beauty for all hair types in ten minutes flat.

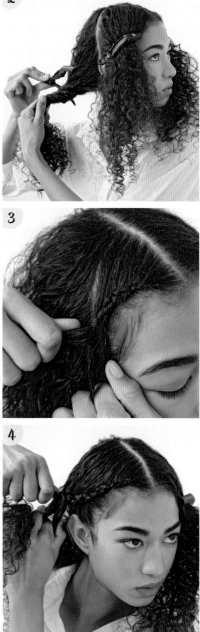

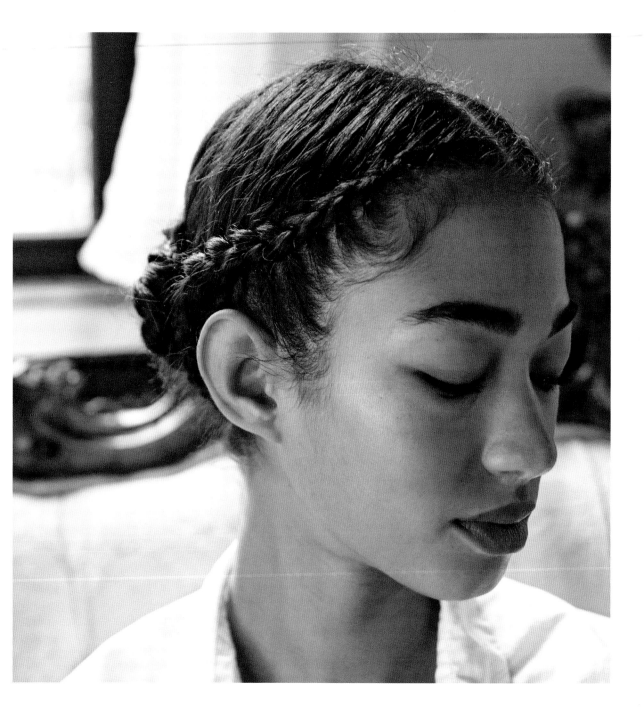

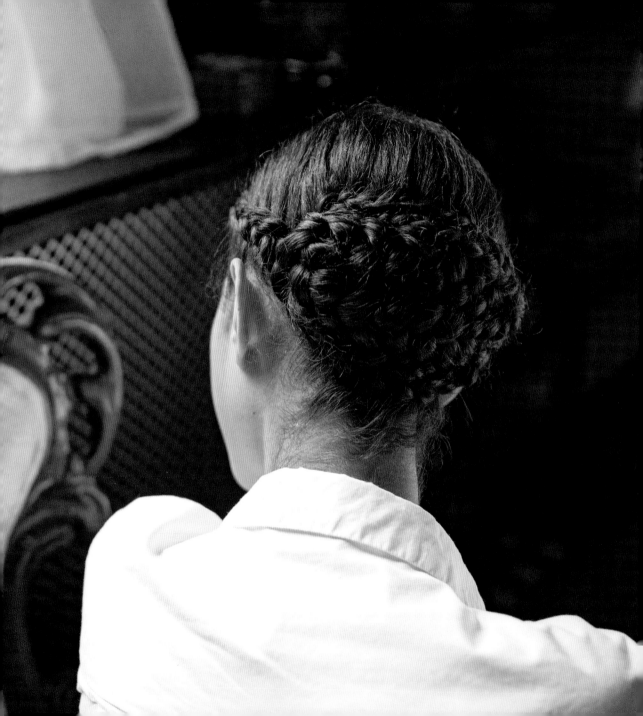

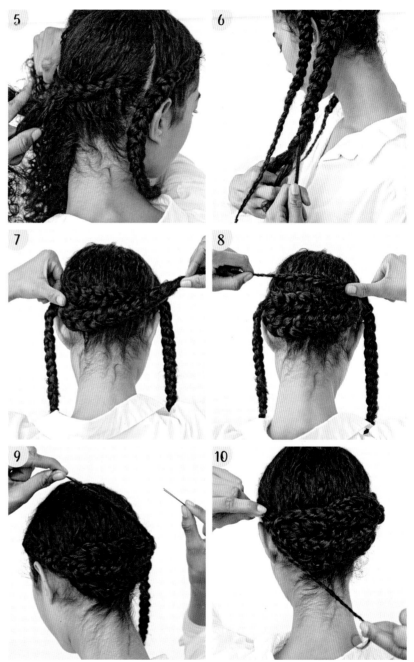

5 Move on to the section at the back of your head. Starting just behind where one braid leaves off above your ear, pick up three small sections and weave a Dutch braid from one side of your head to the other, staying close to your head until you've braided all the hair at your scalp.

6 Continue braiding until you run out of hair. Finish with a small rubber band.

7 Grab the end of the braid and fold the loose part up onto the back of your head. It should form a row right below the first half of the braid. Use small hairpins to secure the braid along the perimeter, especially at the fold.

8 Fold and extend any excess braid over the top of the middle braid so it rests on your scalp. Pin along the perimeter and at the fold, then tuck the ends under the braid and pin in place. Weave a couple of small hairpins between the braids to secure them together.

9 Repeat with the braid on the left side, extending it across the back of your head so it rests on top of the first braid. Fold it and bring its end back across your head. Secure along the braid's perimeter with small hairpins, then tuck the ends under the braid. Weave small hairpins between this braid and the other braid, too.

10 Bring the braid on the right side straight across the back of your head, piling it on top of the other braids. Fold it down and pin it in place, then wrap the end down below the braid and pin its end. Weave small hairpins between this braid and the others to anchor the look.

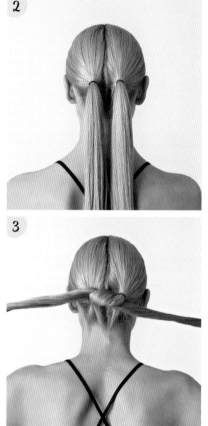

TIE KNOTS INTO A

Modern Chignon

Tie two simple pigtails over and over to achieve a chic, geometric chignon. Don't be shy about using product—it will make your hair sleek and easy to work with.

1 Liberally apply a thick styling cream all over damp hair and blow-dry it with a flat mixed-bristle brush so it's straight but malleable. (See page 21 for my frizzless blowout tutorial.)

2 Use your tail comb to create a clean middle part down the back of your head. Then brush the two sections back and gather them into two low pigtails close to the middle of your nape. Secure them cleanly with small rubber bands. (If you have thick hair, use elastic bungees.)

3 Before knotting the pigtails, brush them and seal in the smoothness with hairspray. Then gather one in each hand and tie them together, pulling the knot as close to the scalp as possible.

4 Knot the pigtails again, pulling the ends taut. Keep knotting until you're almost out of hair, positioning new knots around the first two knots to create a fuller shape.

5 Wrap the ends of the pigtails around the outer edges of the knots, pinning as you go with bobby pins. When you run out of hair, pin the ends under the knots, then tuck in any strays with small hairpins. Mist with hairspray so it's secure.

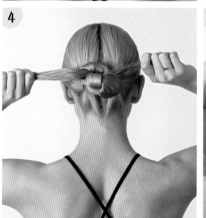

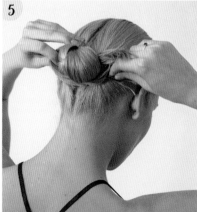

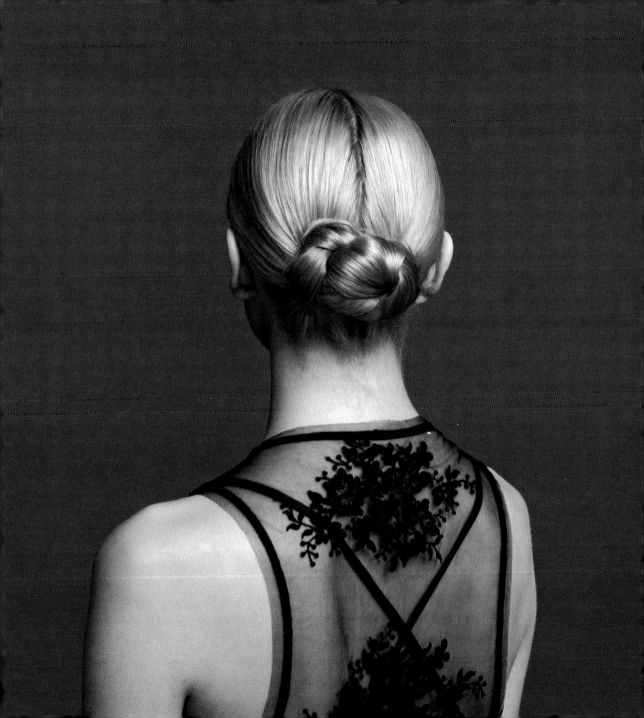

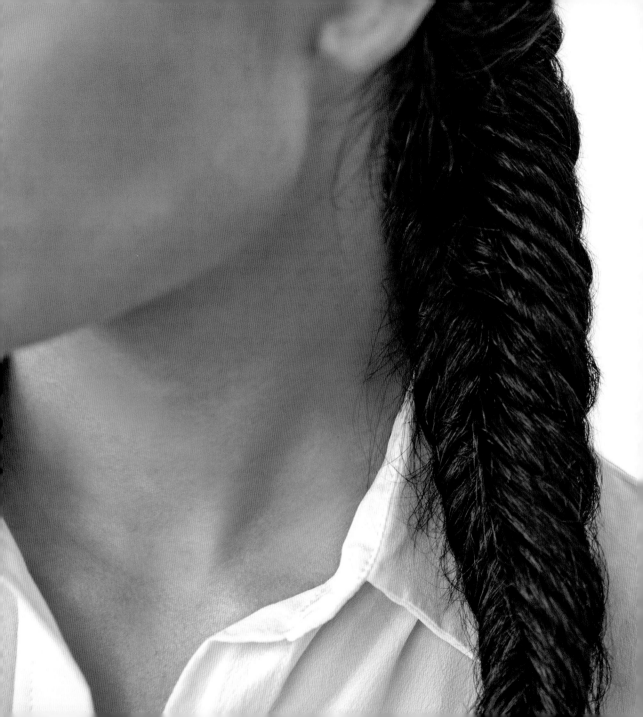

Braids

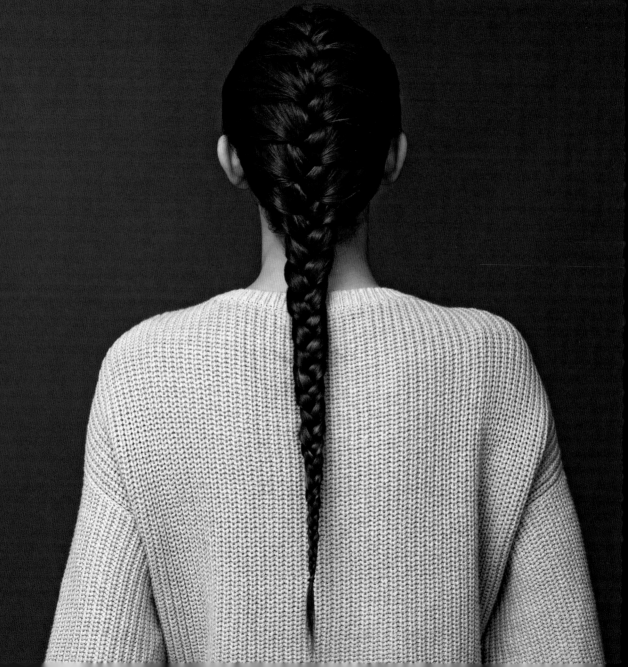

YOU'LL NEED
- **Small rubber band**

THE ART OF THE
French Braid

To create this classic, take hair from one side of the braid and add it to each section before crossing it over the middle. The result is a chic, woven look that's so good the French had to claim it as their own.

1 Take a clump of hair above your forehead and divide it into three equal sections. Use the thumb and index finger on your left hand to hold the section on the far left. Slide the one on the far right between your right hand's thumb and index finger, and hold the middle section between your middle and index fingers.

2 Now bring the section on the far left over the middle one so it's in the center, passing it to your right hand's middle and index fingers.

3 Bring the section on your far right over the middle, making it the new middle.

4 Repeat step 2, but this time add a long, skinny segment of hair from your left side before bringing the section over the middle. To gather the hair, use your finger to draw a line from your hairline to the braid, moving your fingertip close to the scalp. Then tuck these gathered strands into the section. Try to make equal sections every time.

5 Braid until you run out of hair to gather, incorporating all strands before you reach your nape. Then continue with a three-strand braid, bringing the outside sections over the middle until you reach the ends. Secure it with a rubber band.

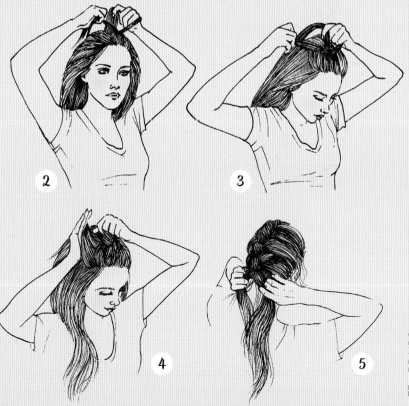

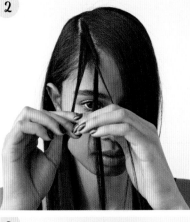

2

BRAIDED

Bohemian Bangs

Trying to grow out your bangs? Disguise them with a face-framing Dutch braid—they'll be gone before you know it.

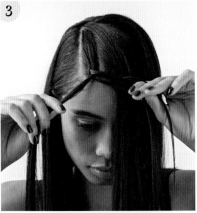

3

1 Use your tail comb to create a deep side part, then make a triangular section extending from the crown of your head to the middle of both brows. Then separate out a 1-inch (25-mm) section closest to your part.

2 Divide this section into three sections. Then bring the back section under the middle, making it the new middle. (This is what differentiates a French braid from a Dutch: The sections go under, not over!)

3 Repeat with the front section, bringing it under the middle section. Keep the hair close to your scalp.

4 Gather a skinny slice-of-pie section that extends from the center of your head to your front hairline, then add it to the back section and bring the hair under the middle section. Move your hands along your hairline so the braid travels down the side of your face.

5 Keep gathering slice-of-pie sections and adding them to the back section, then bringing them under the middle, until you run out of hair in the triangular section. Continue with a three-strand braid; finish with a small rubber band.

6 Starting at the bottom of the braid and working toward the top, tug at the sides to widen it and create texture.

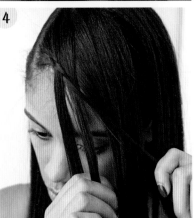

4

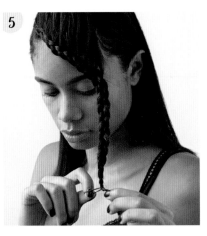

5

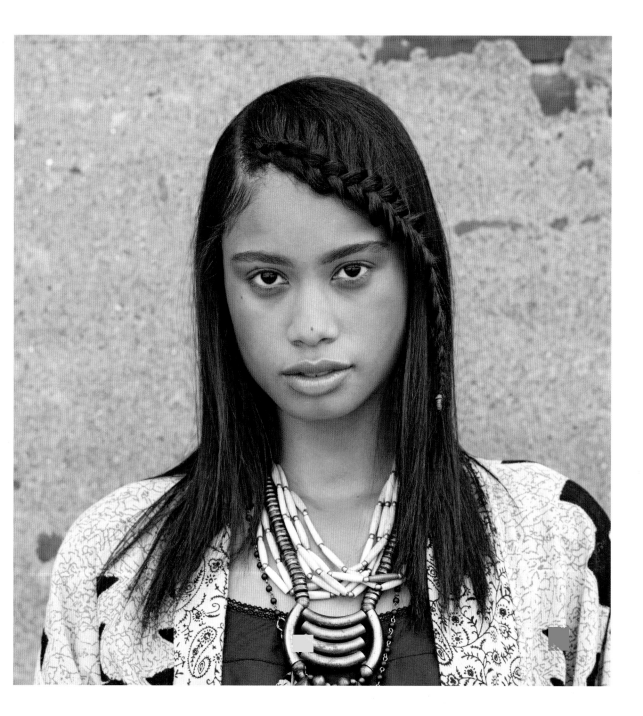

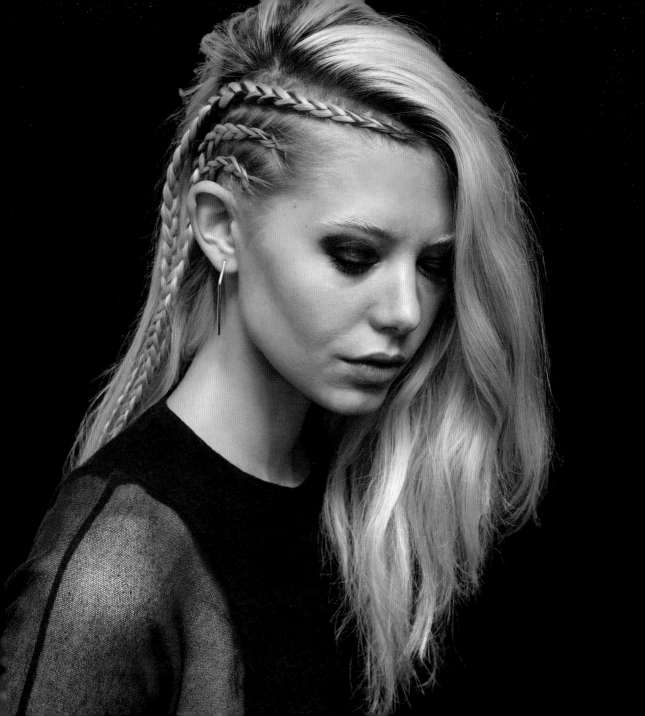

YOU'LL NEED
- Tail comb
- Two silver duckbill clips
- Wax
- Three small rubber bands
- Saltwater spray
- Blowdryer without nozzle

OPTIONAL
- 1-inch (25-mm) curling iron
- Texturizing spray

Edgy Cornrows

WITH DISHEVELED WAVES

Teeny cornrows—aka Dutch braids—can add a little toughness to your look. To save time (and create contrast), just do a few and let the rest of your hair hang loose.

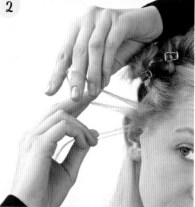

1 Use your tail comb to create a clean, diagonal part that starts at the center of your front hairline and ends at a point between the top of your head and your right ear.

2 Make three tiny sections on the right side of your head with your tail comb. Clip the top two sections out of the way with silver duckbill clips. Then take the section closest to your ear and divide it into three mini sections.

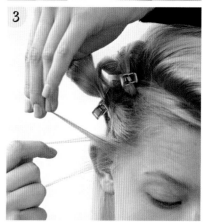

3 Add wax to your fingers before braiding for better grip. Then start your braid by crossing one side section underneath the middle section.

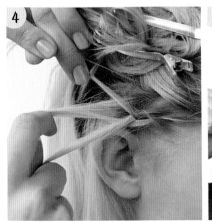

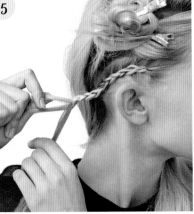

TIP
Adding wax to your fingers before braiding will give you better grip and slick down any stray baby hairs. Put some on the back of your hand so you can pick it up as needed without reaching for the container.

4 Continue bringing the outside sections under the middle. Each time you do, pick up hair from either side of the braid and incorporate it into the working strand. Braid close to your scalp and move your hands back along your head. (If you braid with your hair pulled out so you can see it, your cornrow won't lie properly against your head.)

5 When you run out of hair close to your scalp, switch to a regular braid while maintaining your body positioning so the braid stays behind your ear instead of coming forward toward your face. Finish it off with a small rubber band.

6 Braid the two remaining sections like the first. Then mist saltwater spray on your loose locks from roots to ends and remove the nozzle from your blowdryer. Blow-dry your hair while scrunching it with your hands. (If you have really curly hair that frizzes when wet, skip this step and use a curling iron to enhance your natural curls—see page 121.) Or blow-dry it straight and then add a loose wave with a 1-inch (25-mm) curling iron instead. Finish with a mist of texturizing spray.

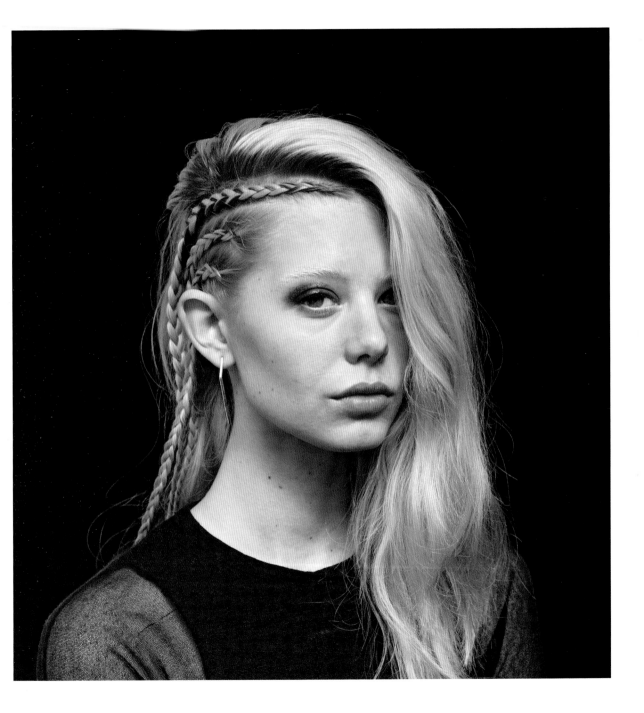

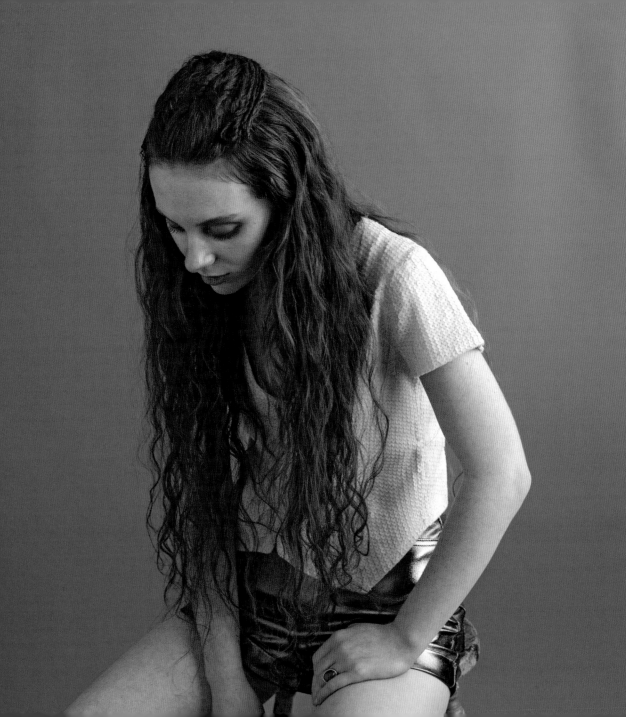

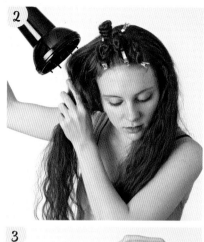

YOU'LL NEED
- Saltwater spray
- Four silver duckbill clips
- Blowdryer with diffuser
- Small rubber bands
- Small hairpins

SET YOURSELF ADRIFT WITH

Mermaid Braids

Everybody dreams of mermaid hair: long, wave-swept tresses with a few romantic tendrils floating loose. Wrap your crown with tiny, relaxed fishtails to complete the look.

1 Apply saltwater spray on damp hair from roots to ends. Clip three square sections along your front hairline. Pick up a fourth, longer, and horizontal section behind them—it should extend across the top of your head—and clip in place.

2 Add a diffuser to your blowdryer and diffuse all your hair. Encourage texture by twisting large sections with your hands.

3 Now you'll loosely fishtail-braid each of the four sections. Divide a section into two. Gather a few strands from the far side of one section and cross it over the middle, letting it join the second section. (See page 90 for the full tutorial.) Keep gathering and crossing the hair, pulling the braid back toward your crown.

4 Repeat with the other sections, tying each off with a small rubber band. Pull the braids from both sides to widen them.

5 Wrap one braid in a flat loop around your crown and extend it up toward your front hairline and back again, if length permits. Pin it with a small hairpin, leaving some excess braid loose. Repeat with the other fishtails, alternating from one side to the other, and then pin the loose ends so they fill any gaps between the loops.

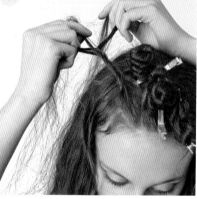

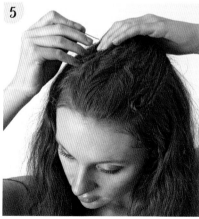

YOU'LL NEED
- **Tail comb**
- **Two small rubber bands**
- **Japanese bobby pins**

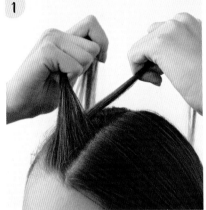

GRAPHIC

Fishtail Loops

Get that hair out of the way with bold, pinned-up reverse fishtail braids.

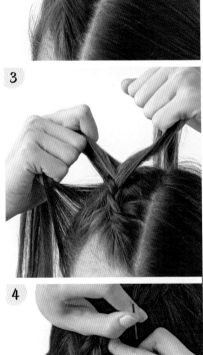

1 Using a tail comb, part your hair down the middle. Gather two sections from your front hairline and cross them so the one nearest your part is on top. Hold your arms so the beginning of the braid is aimed toward the back of your head.

2 Gather a tiny group of strands from the top section (taking it on the side closest to your ear), then bring it under to merge it with the bottom section. Then, to create the reverse fishtail effect, take another small group of strands—this time from the hair closest to your ear that hasn't been incorporated into the section. Bring it under the top section and merge it with the bottom section.

3 Repeat on the other side, gathering a tiny section of hair from the far side of the bottom section and crossing it under to merge it with the top section. Then gather hair from outside of the braid, bringing the strands under to combine it with the far section. Keep going until you run out of hair close to your scalp.

4 When you reach your neck, continue with a reverse fishtail; finish it with a rubber band. Fold the braid's end up toward the base of your neck, forming a loop. Pin the ends of the braid into place using strong bobby pins, then repeat the entire process on the other side.

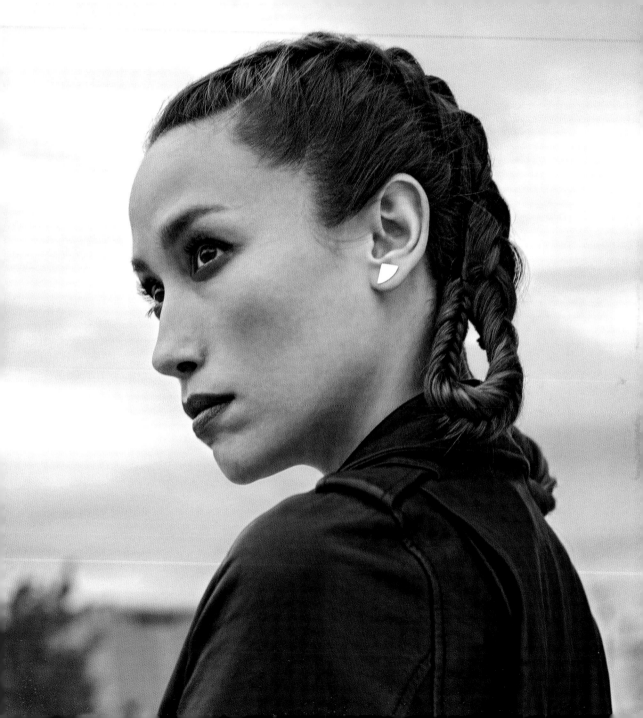

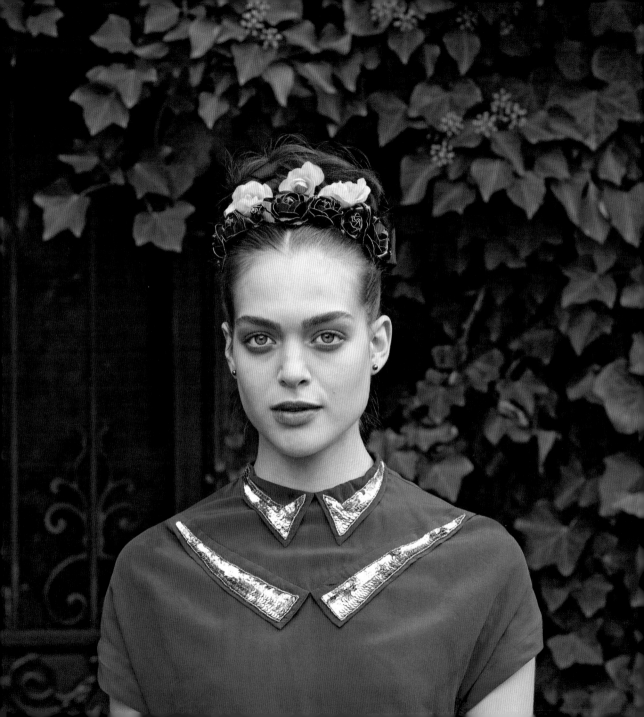

YOU'LL NEED
- Tail comb
- Two crocodile clips
- Light-hold hairspray
- Flat boar-bristle finishing brush
- Two elastic bungees
- Ribbon that's twice as long as your hair
- Silver duckbill clip
- Two small rubber bands
- Small hairpins
- Floral headbands

VARIATION
- Flowers with at least 2 inches (50 mm) of stem
- Large hairpins

Frida-Inspired PLAITS

I've always been empowered by Frida Kahlo's story and admired her bold, unconventional femininity. It's no surprise I love her signature hairstyle, too.

1 Use your tail comb to part your hair all the way down the middle, dividing it into two equal sections on either side of your head. Secure with two crocodile clips.

2 Gather one section into a pigtail just below your crown and 1 inch (25 mm) away from the center part. Blast the section with hairspray and smooth it back with your flat boar-bristle finishing brush so it's tight, then secure it in place with an elastic bungee. Repeat with the other pigtail.

3 Place the ribbon on top of your head so it straddles the gap between the pigtails. Gather them in your hands so the ribbon is incorporated in both.

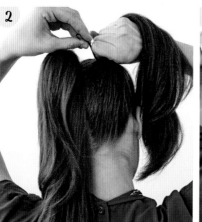

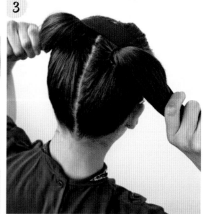

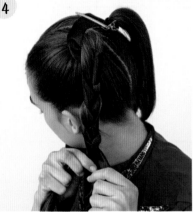

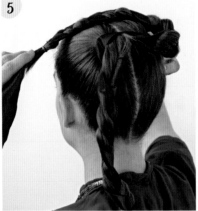

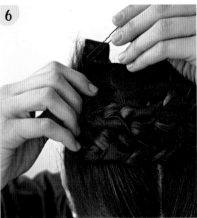

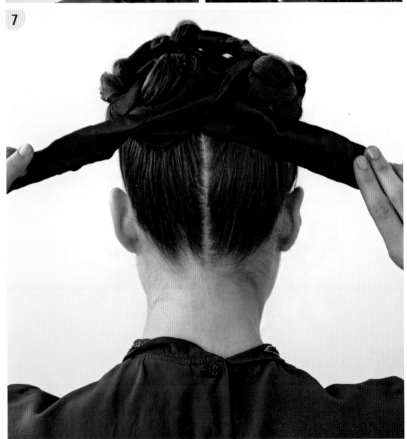

4 Use a duckbill clip to temporarily hold the ribbon on one side of your head, then split the other pigtail into three sections with the ribbon in the middle. Weave the pigtail into a classic three-strand braid, and secure it with a small rubber band. Repeat with the other pigtail.

5 Bring one braid over the front of your head and across your part like a headband. (If you have long hair, you may need to cross it multiple times until it's all piled on your head.) Secure it in place with small hairpins.

6 Repeat with the other braid, pinning it down with small hairpins. Make sure to tuck and pin the ends.

7 You can tie the excess ribbon into a knot or bow at the back of your head and let the ends dangle, as shown here, or you can trim the ends and tie them off for a more tidy style.

8 Top off your look by placing floral headbands in front of the braids and pinning them in place.

For a fresh alternative, stick the stems of real flowers into your braids, focusing on the top center of your head. Then slide large hairpins over the stems and your hair to secure the blossoms in place.

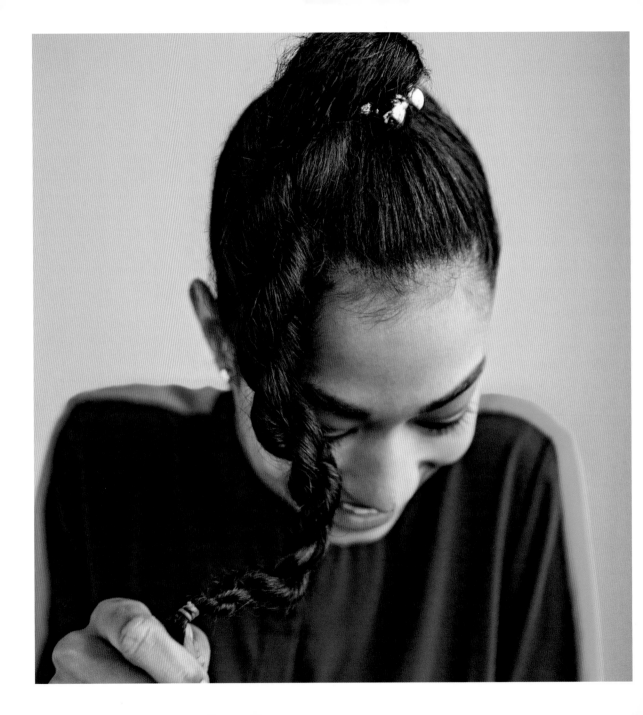

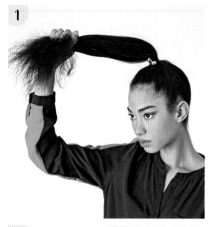

1

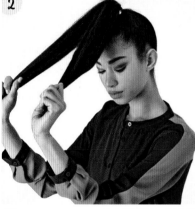

2

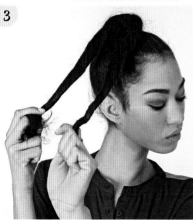

3

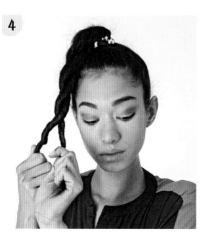

4

YOU'LL NEED
- Flat mixed-bristle brush
- Elastic bungee
- Dry shampoo
- Wax
- Small rubber band

PLAYFUL

Rope Braid

A high ponytail gets a hip twist. Tie it off with hair baubles borrowed from your childhood for an eye-catching look.

1 Brush all your hair into a high ponytail with a flat mixed-bristle brush, then secure it with an elastic bungee. Liberally spray dry shampoo on the ponytail.

2 Split the ponytail in half so you have two equal sections. (If you have layers, make sure the length on both sections matches so one section isn't a lot longer than the other.)

3 Rub a small amount of wax into your hands so they're shiny—this will make braiding easier and stray hairs stick back in place. Take your two sections and twist them in the same direction.

4 Once you've twisted from roots to ends, wrap the sections around each other by passing the twist in your right hand to your left hand and grabbing the one that was originally in your left hand with your right. Continue twisting the sections as you wrap them.

5 Secure the ends with a small rubber band and spray the braid with more dry shampoo for added texture.

ROMANTIC
Fishtail

Crisscross tiny strands of hair for an elaborate look that's surprisingly easy to do.

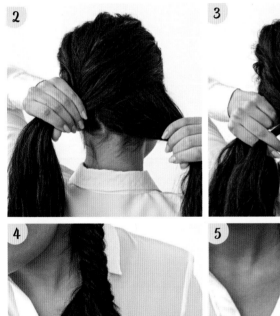

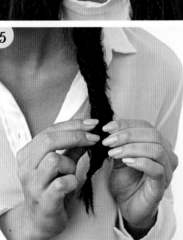

1 Start by adding a little texturizing spray to your hair, then gather it all back with your hands. Split your hair in half and hold one half in each hand.

2 Take a sliver of hair from the far side of your right section and bring it over to the left, merging it completely with the left section.

3 Keep trading slivers back and forth between the sections, gathering a sliver from the far side of a section, crossing over the gap between the two sections, and incorporating it into the second section. Try to keep the slivers the same size so your braid is even. And make sure you're holding your hair tightly at the braid's base for the first few swaps to keep all the crisscrosses in place.

4 When you get to the nape of your neck, drape your hair around one shoulder to continue the braid, bringing one arm under your chin and across your chest to keep braiding. The sections should get smaller and tighter.

5 When you run out of hair, finish the braid off with a small rubber band. To create extra-touchable texture and make the braid wider, grab your braid from both sides and pull outward. Start at the bottom of your braid and stretch it as you work your way up to the top.

VARIATION

For a playful splash of color, weave a skinny ribbon into your fishtail. Fold a long ribbon in half, and at its crease tie it around a small section of your hair, as close to the roots as possible. Then braid as usual, occasionally trading the ribbon back and forth with the sections.

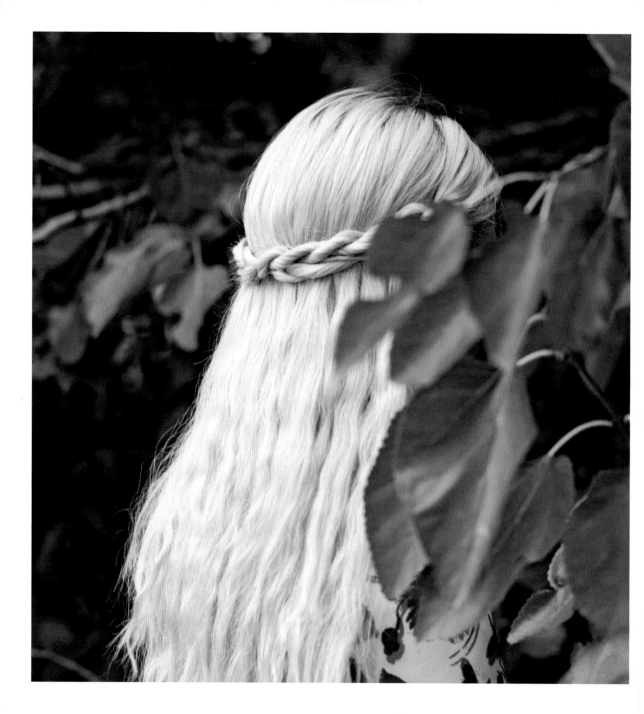

2

ETHEREAL

Half-Up BRAID

Perfect for summertime picnics and forays in the park—and for any hair length or texture.

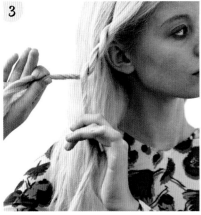

3

1 Spritz saltwater spray all over your hair and blow-dry it in (with the nozzle removed from your blowdryer for a more natural texture), then use your fingers to create a middle part.

2 Use a tail comb to create a part extending from behind your right ear to the crown of your head. Separate these two sections with silver duckbill clips. Repeat on the left side. Apply dry shampoo from the roots to the ends of the front sections, then smooth the hair flat against your head with your hands.

3 Starting on the right, divide the front section in two and twist each in the same direction, then wrap them around one another as you angle the braid toward the back of your head. (See page 89 for more rope-braid instructions.) Finish it off with a small rubber band when you reach the ends, and repeat on the left side.

4 Bring the rope braid on the left side behind your head so it creates a little headband under your crown. Pin it in place with a small hairpin. (If your hair is really long, double back and then layer the lengths across each other.)

5 Take the rope braid on the right side across the back of your head and pin it with small hairpins. (You can even cross the second braid under and over the first braid, if length permits.) Tuck the ends behind the braids and pin in place.

6 For extra security, weave more pins into your braids where they connect.

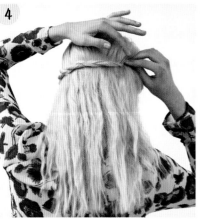

4

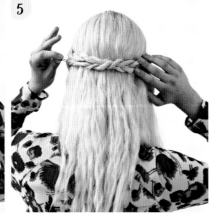

5

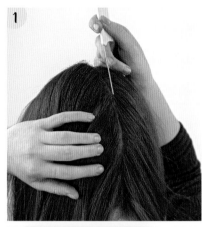

YOU'LL NEED
• Styling cream
• Tail comb
• Two rubber bands
• 3-inch- (75-mm-) long piece of cotton-covered elastic

LINK YOUR PLAITS FOR
Peruvian Charm

I noticed lots of connected braids in Cusco, Peru—paired up with full skirts, bold cardigans, knee-high socks, and brogues. You can top it off with a menswear-inspired hat for a little more attitude.

1 Apply styling cream from the middle of your hair to its ends. Using your tail comb, create a center part from your front hairline to the nape of your neck.

2 You should now have two equal sections of hair on either side of your face. Divide one section into three and weave them into a standard braid, starting close to the back of your head. (Resist pulling the braid forward over your shoulder—this will only create problems when you pull the braids back to connect them.) Secure the end temporarily with a small rubber band.

3 Repeat on the other side so you have two braids going down your back.

4 To connect the braids into a continuous hoop, overlap their ends and drape the elastic over the center where the braids meet. Wrap the excess of one elastic end up one side of the braided loop to the point where the braids stop overlapping, then wrap it back down to reach the center again. (Don't pull too tightly on your elastic as you go.) Knot both ends to make your unibraid for keeps, then trim the excess on the other side of the knot.

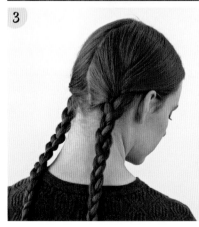

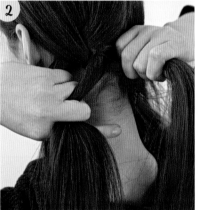

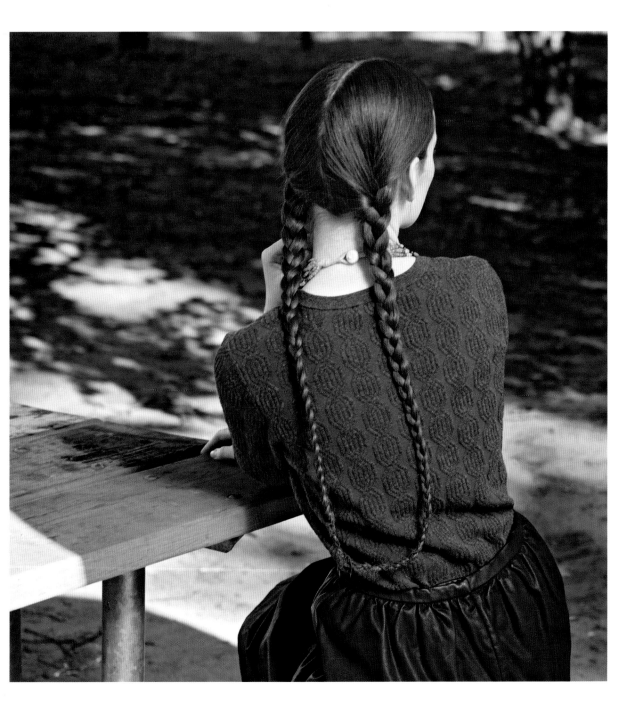

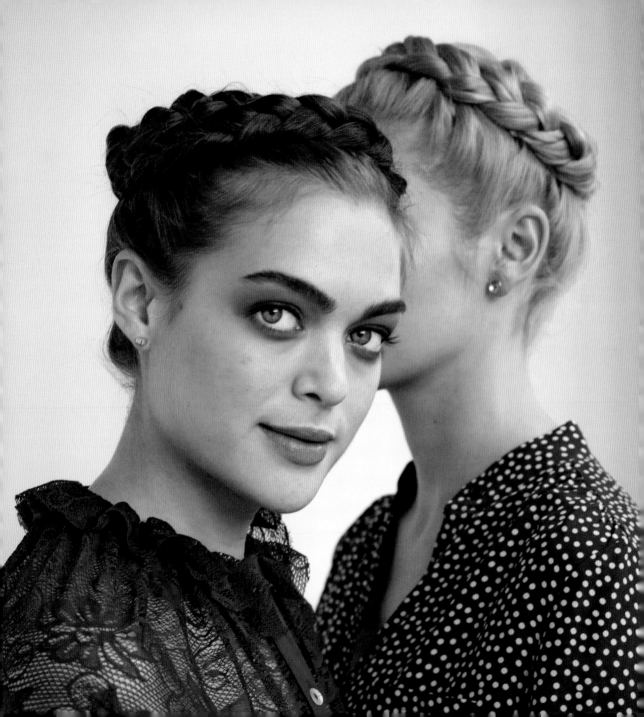

CIRCLE YOUR HEAD WITH A VICTORIAN

Crown Dutch

BRAID

Borrow from another era with one of my all-time favorite looks. Versatile yet intricate, you can pile it on your head and leave it for a week—it'll get better as the days go by.

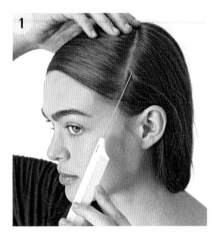

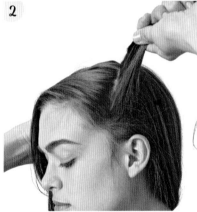

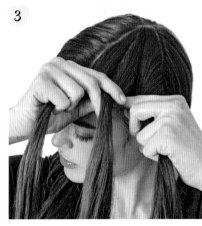

1 Spray dry shampoo all over your hair to give it a workable texture. Then use a tail comb to create a very deep side part, extending from your temple to the center of your crown.

2 Use the tail comb to make another part, this time from the center of your crown to above your ear, creating a small, triangular slice-of-pie section.

3 Split the pie section into three even sections to start your Dutch braid. (A Dutch braid is similar to a French braid in that you gather hair into the sections as you weave, but instead of crossing the sections over the middle, you bring them under the middle.)

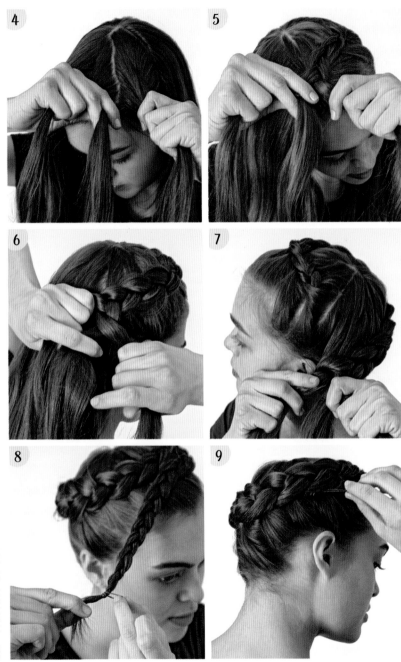

4 Working close to your head, bring the hair nearest to your part under the middle section, making it the new center section.

5 Continue bringing outside sections under the middle, but begin incorporating loose hair as you go. Weave in a section from your hairline, then alternate with an equally sized section that radiates from the center of your crown, and repeat.

6 Keep your arms along the top of your head as you go so the braid stays close to your scalp and circles your crown.

7 When you reach a point behind your opposite ear, switch up your arm positioning: While holding your braid with the hand closest to your ear, bring your other arm under your chin to continue braiding. Don't fret if you lose your spot in the transition—the key is to just keep braiding and stay close to your scalp. Sometimes these braids look best when they're a little imperfect!

8 Once you've completely encircled your head and gathered all your loose hair, continue with a classic three-strand braid. Finish it off with a small rubber band.

9 Wrap the loose plait over the crown braid. Pin the ends under the braid with Japanese bobby pins, then add small hairpins around the braid's perimeter for extra security.

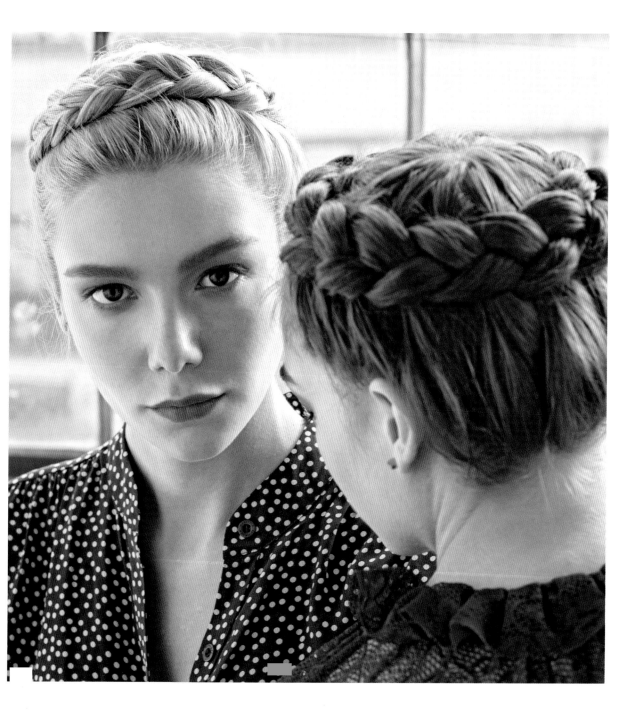

Twists
+
Rolls

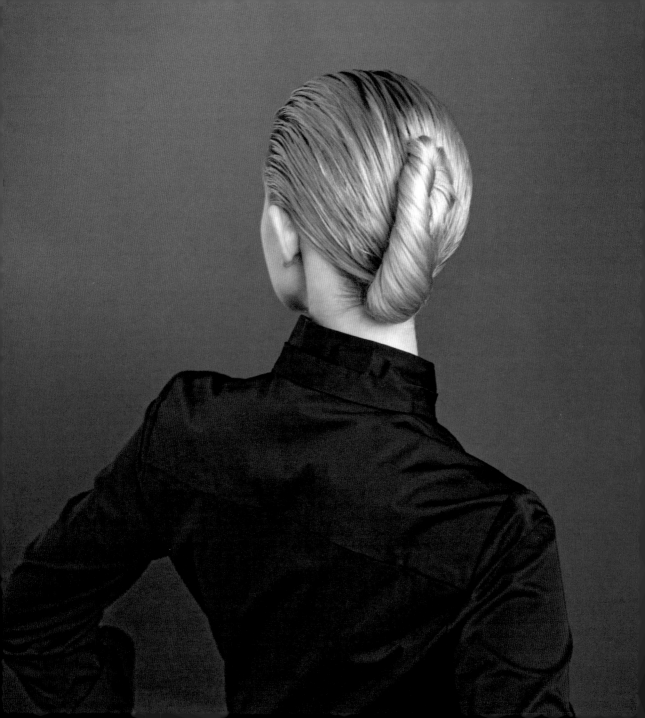

THE ART
OF THE
Twist

Sleek and simple, this twist is truly no-fuss—you can step out with confidence, even if you have zero AM prep time. Wear it soft and natural, or slick it back with gel for a more streamlined take.

YOU'LL NEED
- **Lightweight styling cream**
- **Detangling brush**
- **Elastic bungee**
- **Bobby pins**
OPTIONAL
- **Flat iron**
- **Gel**

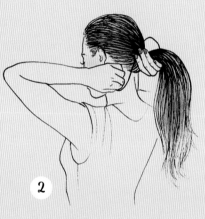

2

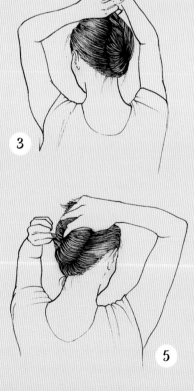

3

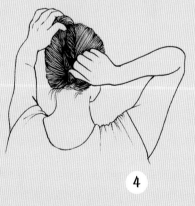

4

5

1 Apply a lightweight styling cream to your hair from roots to ends—this will make slicking it back and twisting it easy without resulting in a look that's too severe. (If you have curly hair, straighten it with a flat iron first.) Focus on the top of your head, which will show the most.

2 With a detangling brush, sweep your hair into a low ponytail, then secure it in place by hooking the end of an elastic bungee to your hair, wrapping the elastic around your ponytail, and then hooking the other end around the elastic. Rake your fingers through your hair to create some texture. We're going for natural ridges rather than a supersleek surface.

3 Tightly twist the hair in your ponytail upward until you reach your ends. It should want to coil a little bit and fold onto itself—that's a good thing.

4 Fold the twist over to one side so the ends point toward the nape of your neck. Depending on your hair's length, you may need to fold it up and down several times.

5 Hold the twist with one hand and use your other hand to insert strong bobby pins into both sides so the twist doesn't move. Be sure to hide the ends.

103 • TWISTS + ROLLS

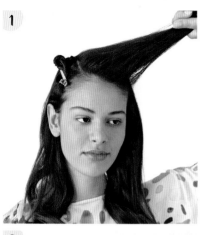

1

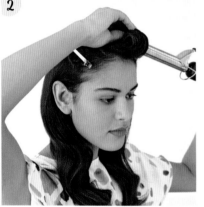

2

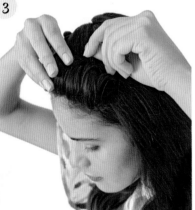

3

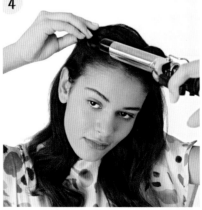

4

WIN THE DAY WITH
Victory Rolls

You've likely seen this retro style in old WWII pinup calendars. This is my ode to the 1940s staple: a little more casual, a little less dramatic, but still totally something to write home about.

1 Starting with perfectly dirty texture, part your hair on one side using a tail comb. Then create a small triangular section by bringing the tail comb from the end of the part to just above your ear. Secure this triangular section with a silver duckbill clip. Repeat on the other side with a larger section.

2 Using a ¾-inch (19-mm) curling iron, curl the larger section back and away from your face. (Curl as close to the roots as possible to avoid creasing your hair along your hairline.) Once the curl is hot, release the clamp and gently pull the iron out, holding onto the roll with your other hand. You can insert a finger into the roll to keep the shape as you remove the iron.

3 Insert small hairpins along the back of the roll and perpendicular to your hairline. If the roll doesn't feel secure, slide a few bobby pins through its center—just make sure to hide them! Spritz it with hairspray.

4 Wrap the small section around the iron, then release the clamp and remove the iron from the roll, holding the roll with your fingers. Pin the back with vertically placed hairpins again, securing it at the center if needed. Mist with hairspray.

TIP

Once your victory rolls are in place, you can style the rest of your hair however you want! To re-create the curls here, start with a smooth blowout (see page 21), then loosely curl five or six sections with your curling iron held vertically.

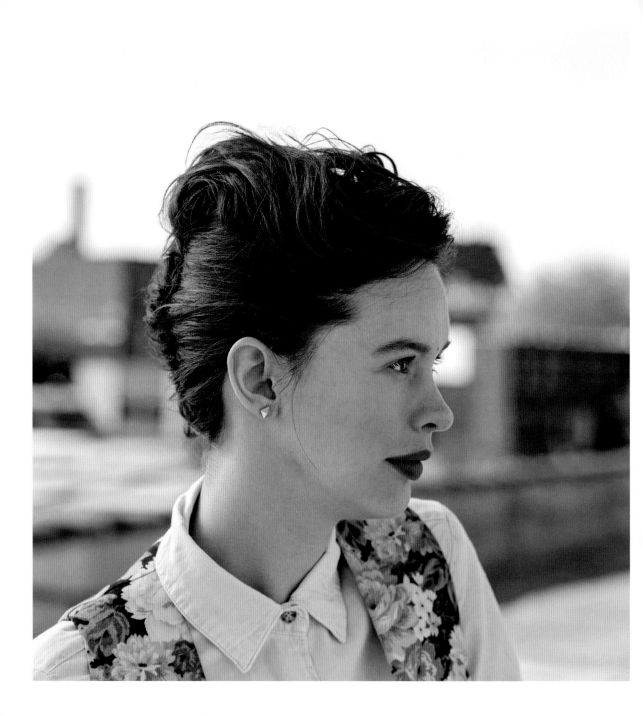

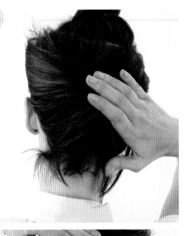

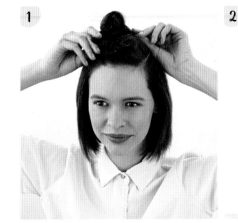

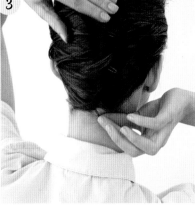

TEASE UP A
Pixie Twist

1 Start with perfectly dirty hair, then spritz your hair with texturizing spray—the more product you use, the better! Using a tail comb, make a U-shape section from the peak of one eyebrow, back to your crown, and then forward to the other eyebrow's peak. Hold this section in place with a crocodile clip.

2 Backcomb your hair in vertical sections, focusing on the middle back of your head, then put pomade on your hands. Gather it into a ponytail with your thumb and index finger farthest from your head. Rotate your wrist to the left or right so your thumb and index finger are closest to your scalp, creating a twist. Tuck your loose hair into the resulting pocket.

3 Insert large hairpins into the twist horizontally, then shape it and secure with smaller hairpins. Remove the large hairpins once the twist is tight. Tuck up

Prim twist in the back, spitfire curls in the front—this look is perfect for girls with bobs. And for sneaking up on rooftops, but you didn't read it here.

and pin any loose strands on your neck. A little hairspray will help, too.

4 Take down the U-shape section of hair and curl it so the ringlets go in different directions—you want this section of your hair to look a little disheveled!

5 Let the curls cool, then separate them with your fingers and use your tail comb to tease them at the roots and blend them together. (If you have longer hair, pin the curls back into the twist with hairpins.)

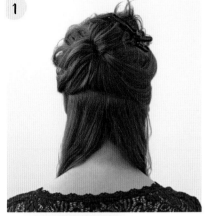

YOU'LL NEED
- Crocodile clip
- Two small rubber bands
- Small hairpins
- Silver duckbill clip
- Hairspray
- Bobby pins

SURPRISE WITH A

Faux Bob

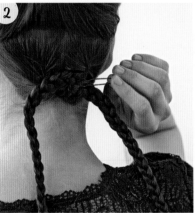

I love having long hair, but I'm really a short-hair girl at heart. Luckily, with some sneaky braids and a few bobby pins, we can all fake a bob for a day.

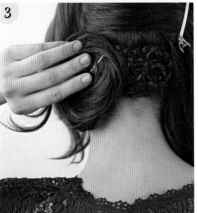

1 Make a rough part at the back of your head from ear to ear and secure the hair on top with a crocodile clip. Divide the remaining hair into two equal sections.

2 Braid the two sections and finish each with a small rubber band. Then lay them across each other and pin them flat against your head with a small hairpin. Create a rectangle of braids by wrapping them around each other and weaving hairpins between them. This creates a cushion to pin your faux bob to.

3 Gather a 2-inch- (50-mm-) wide section of hair from the tresses on top of your head, keeping the rest out of the way with a silver duckbill clip. Hairspray this section and tuck it up and under, pinning it to the braids with a bobby pin.

4 Continue to tuck, fold, and pin, keeping your hair's "new length" consistent as you go.

5 Finish the look by casually pulling a few wisps out around your face to create a more natural bob effect.

YOU'LL NEED
- Root lifter
- Blowdryer with nozzle
- Tail comb
- Three crocodile clips
- Silver duckbill clip
- Two bobby pins
- Flat boar-bristle finishing brush
- Large hairpins
- Small hairpins
- Hairspray

THE CLASSIC

French Twist

Get a little *je ne sais quoi* in your look with a French twist, first popularized by Catherine Deneuve and Brigitte Bardot in the '60s and still a hit on the runway today.

1 With this style, product is your best friend, so spray root lifter liberally from roots to ends. Then blow-dry it in, using just your fingers to comb your hair high on the back of your head for a beautiful, upswept shape.

2 Use your tail comb to make a U-shape section at the top of your head, extending from one eyebrow, across the back of your crown, to the other eyebrow. Then separate the rest of your hair into two sections down the back. Hold each in place with a crocodile clip.

3 Unclip one of the back sections. Starting at the center of your head, tease your hair close to the roots, inserting the tail comb's teeth every few centimeters at first and then gradually in longer increments as you work your way to the ends. This will create texture, making your twist easier to wrap and pin into place.

4 Continue to tease the back section, moving out from the center of the back of your head toward your face, lightening up as you go so the hair is less teased along the hairline. Unclip the other back section and repeat.

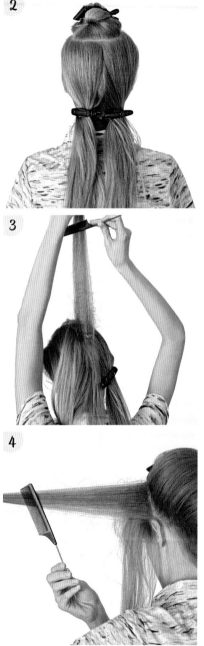

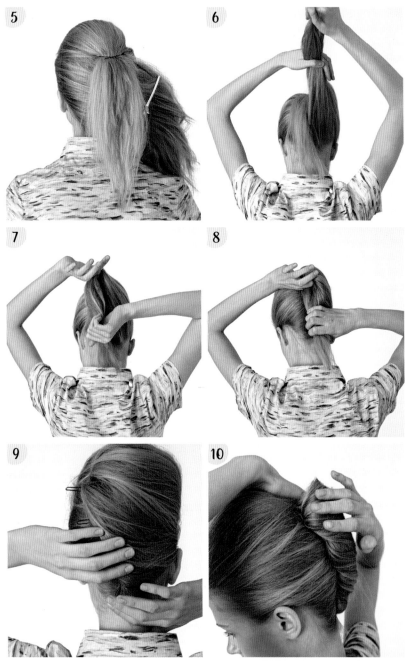

5 Clip the two back sections to one side with a silver duckbill clip. Then backcomb the U-shape section, lightening up as you reach your hairline, and secure it below your crown with an X of two bobby pins.

6 Lightly smooth the hair around your hairline with a flat boar-bristle finishing brush, then pull your hair to the center back of your head (leaving out the U-shape section). Hold it loosely in a ponytail, grasping it about 2 inches (50 mm) off your scalp. Your thumb should be far from your head and the palm of your hand should face down.

7 To create the twist, rotate your wrist to the right or left so your palm faces up. This motion will pull most of your hair taut against your head, with the ends hanging loose and pointing downward.

8 You'll sense a pocket underneath your thumb and index finger. While still holding onto your hair with your nondominant hand, twist the loose ends and start tucking your hair into the pocket. Be sure to incorporate all the ends of the U-shape section, too. (If you have long hair, you may need to fold your twist a few times to fit it all in.) Make the twist long and skinny, lengthening it so it just covers the X of bobby pins.

9 Starting at the nape of your neck, insert large hairpins horizontally into the twisted underside while maintaining a firm grip on the twist.

10 Once the basic shape is secure, let go of the twist and add smaller hairpins to the twisted underside, working your way up from the bottom. You can withdraw the large hairpins once the smaller ones are in place, then mist with hairspray.

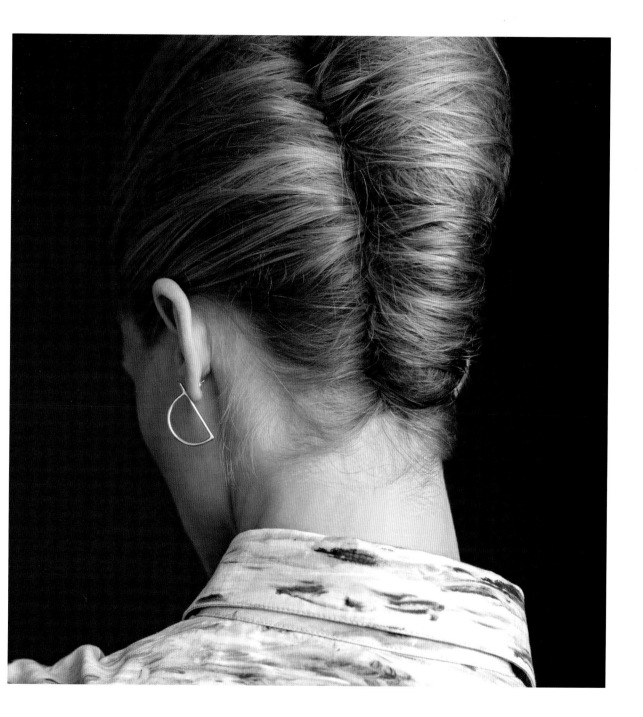

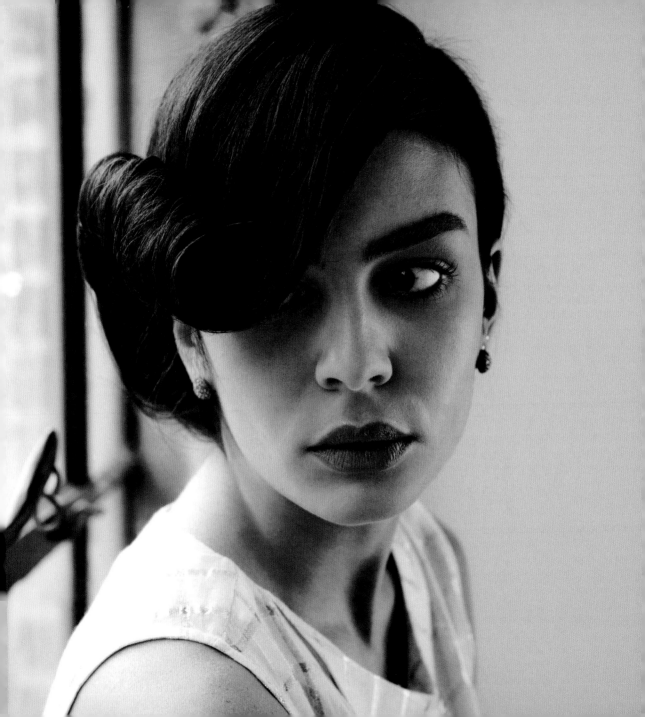

YOU'LL NEED
- **Styling cream**
- **Flat mixed-bristle brush**
- **Two chopsticks**
- **Large hairpins**
- **Small hairpins**
- **Bobby pins**
- **Hairspray**

1

2

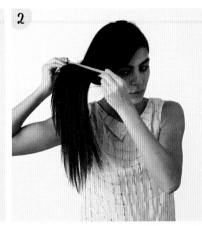

3

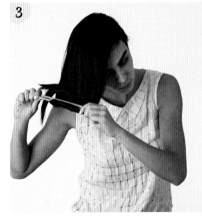

4

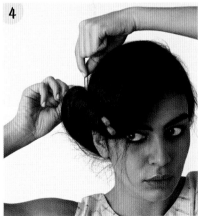

DRAMATIC

Side-swept Roll

The thing I like most about this coy, wrap-around twist is that it covers one eye up just a little bit. Also, chopsticks make rolling it a cinch.

1 Put styling cream on your hands—it will transfer to your hair as you go. Create a side part, then brush all your hair to the other side with your flat mixed-bristle brush. Shape it so it covers one eye.

2 Clamp your hair between two chopsticks. Slide them down so they're three-fourths of the way to the ends.

3 Roll the chopsticks up your hair, wrapping your locks around them.

4 Stop when your roll extends tightly from one eye to the back of your head. Secure the roll to the hair against your scalp with large hairpins.

5 Pull out the chopsticks and tweak the twist for desired shape. Insert small hairpins and bobby pins across the twist, moving from back to front. Remove the large hairpins, tuck in flyaways, and seal with hairspray.

YOU'LL NEED
• **Texturizing spray**
• **Large hairpins**
• **Bobby pins**
• **Small hairpins**
• **Hairspray**

TOUGH

Tomboy Twist

Borrow from the Teddy Girls—bad ladies of the '50s with rockabilly style. This look frontloads the drama with one big hoop of hair. You can lighten it up with a few flyaways around your face.

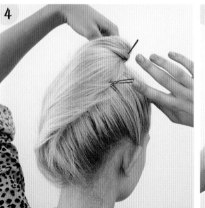

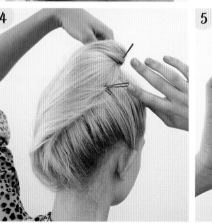

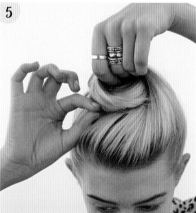

1 Start with perfectly dirty hair—this slightly sticky feel will make it easier to roll and pin. Hit it with texturizing spray from roots to ends.

2 Gather all your hair on top of your head with your thumb and index finger closest to your scalp. Now, while holding onto those locks, rotate your wrist forward to create a roll. Make sure the loose hair falls backward, not toward your face.

3 Insert your thumb into the roll to maintain its shape, then tuck your hair's loose ends into the pocket under your thumb and index finger.

4 While holding onto the swirl, tuck remaining strands into the twist of hair behind the roll. This twist should go down the back of your head like a mohawk, getting narrower toward your nape. Anchor it with a few large hairpins placed horizontally all the way down its length.

5 Starting at the bottom, place bobby pins and small hairpins along the entire twist. Make sure to secure the swirl! Remove the large hairpins when finished.

6 Using the hand that's holding the swirl in place, pull the top of your hair forward to create a looser, more voluminous roll. Then seal the deal with hairspray.

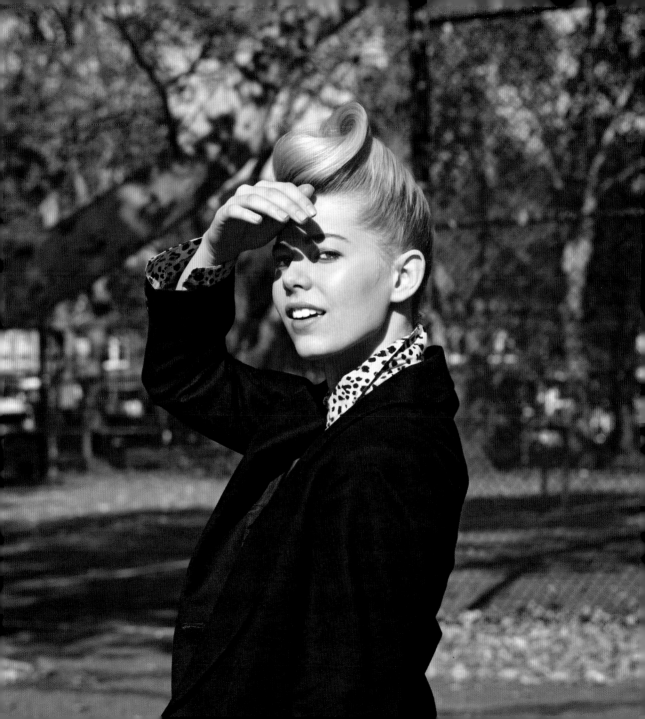

Curls

THE ART OF THE
Curl

Whether your hair is fine and straight or a lot of corkscrew spirals, a curling iron is your best friend when it comes to making waves or creating more consistent, defined ringlets—without the frizz.

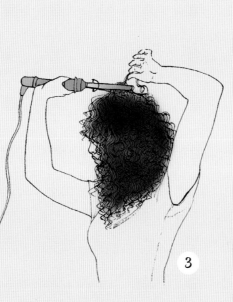

2

3

4

1 Plug in your curling iron and select a heat setting. Ladies with fine hair will want to use a low setting—below 200°F (93°C)—while girls with thicker hair can go higher (up to 300°F/149°C).

2 Divide a section of hair that's the same size as the curl or wave you have—or the one you want! If your hair is already curly, select a section that you'd like to enhance. (For instance, if your curls are less defined on top, first focus your efforts there to give those strands a better overall shape, then move onto less-defined or frizzy curls.)

3 Mist your section with hairspray to protect it from heat. (Replace hairspray with serum if you have really tight curls.) Open your curling iron and wrap your hair around the barrel. For lasting curls, it's always best to start close to your roots.

Clamp the iron shut for more volume at the base or leave it open for relaxed curls.

4 Hold the hair around the iron until it's hot, about 10 seconds. Unspool and pull it taut from the ends—this will stretch it as it cools for a looser, more natural wave.

5 Curl as many or as few sections as you'd like or have time for. You can do a few face-framing waves, for example, or go all-out with all-over curls.

YOU'LL NEED
- Tail comb
- Crocodile clips
- Lightweight hairspray
- Bobby pins

PRIM +
PROPER

Pin Curls

Borrow these bobby-pin-topped swirls from your granny's school-yard days.

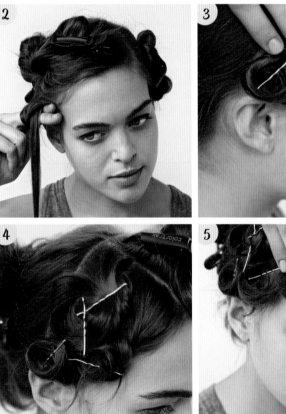

1 Use your tail comb to make a deep part on your left side, then divide your hair into three rough sections: one on either side of your head and one at the back. Hold each section in place with a crocodile clip.

2 Take a 1½-by-1½-inch (38-by-38-mm) section from the larger section above your right ear. Spray it with lightweight hairspray from roots to ends, then begin wrapping it around two fingers, starting with the hair near your scalp.

3 Once the section is wrapped around your fingers, slide them out and press the curl flat against your head. Secure it by sliding a strong bobby pin over its top. (Use bobby pins that match your hair, or go for a contrasting hue, if you please!)

4 Continue taking sections from the large section at the side of your head and curling them around your fingers, then sliding pins over the curls. I like alternating pin-curl sizes so it doesn't look too stern or classic.

5 When you reach your bangs, take a big section and arrange it into a flat loop on your forehead. Wrap the ends around your fingers and pin the curl in place.

6 Move on to the section on the other side of your head, then the section at the back. Mist the whole look with hairspray.

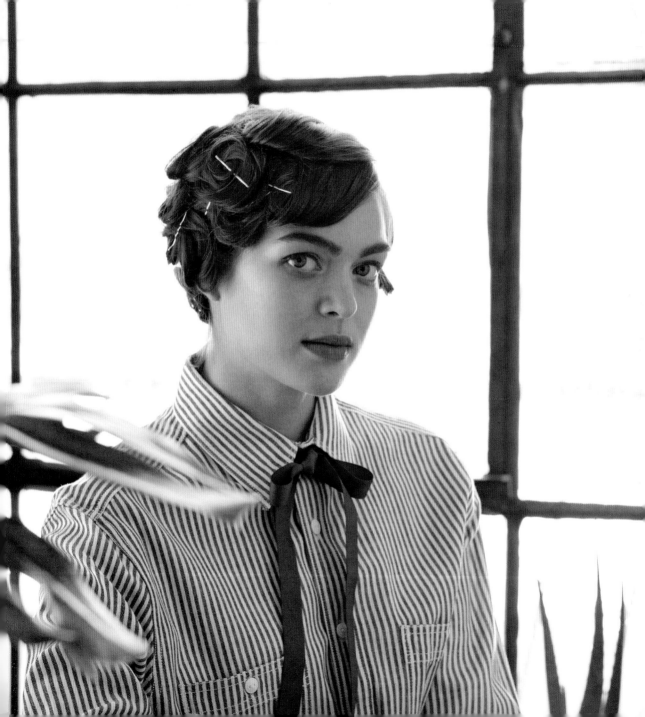

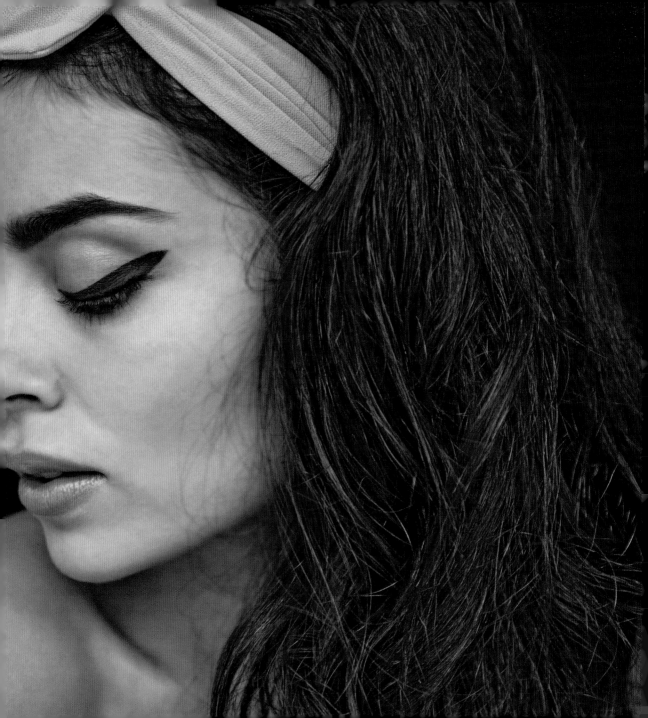

YOU'LL NEED
- Hairspray
- Flat mixed-bristle brush
- Crocodile clip
- 1½-inch (38-mm) curling iron
- Tail comb

OPTIONAL
- Scarf

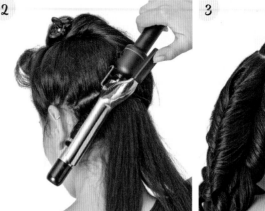

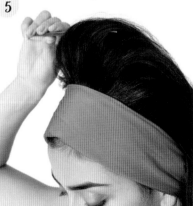

LOOSE + TOUSLED
Beach Waves

Holding your iron just so—and adding a little strategic messiness—will give you just the right bend in your tresses.

1 To make your hair workable, divide it into sections and spray hairspray all over them. Brush it out with your flat mixed-bristle brush and then spray it all again.

2 Make a part from ear to ear at the back of your head, then clip the hair above it. Take a 1½-by-1½-inch (38-by-38-mm) section of hair and apply hairspray again—this will protect your hair from the heat and seal the curl. Holding your curling iron as vertically as possible, wrap your hair around it in a direction going away from your face. Don't clamp the iron shut and gingerly remove once the curl is warm.

3 Repeat with another section, but this time switch it up: Wrap your hair around the iron in the opposite direction. Move on to the rest of your hair in the row, alternating directions as you go. Then remove the clip, create a second row, and reclip your remaining hair. Divide that row into sections and repeat alternating curling directions. Create a third row and repeat curling again.

4 Curl the hair on the top of your head away from your face, then let your curls cool. Separate them by holding all the ends with one hand while shaking the roots at your crown with your other hand.

5 Complete the look with a natural part, or add a scarf for a playful look. If you'd like volume, tease around your crown and then use the tail comb's metal end to lift.

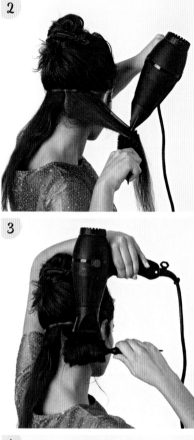

YOU'LL NEED
- **Root lifter**
- **Blowdryer with nozzle**
- **Crocodile clip**
- **1-inch (25-mm) round boar-bristle brush**
- **Several silver duckbill clips**
- **Flat mixed-bristle brush**
- **Hairspray**

NAUGHTY-BUT-NICE

Baltimore Blowout

Believe it or not, this look was inspired by mugshots from the '60s— I love the sassy, bad-girl-out-on-the-town vibe combined with a tried-and-true blowdry set.

1 Starting with towel-dried hair, liberally apply root lifter from roots to ends and pre-dry your roots (see page 18) while creating volume at your crown.

2 When your hair is 80 percent dry, divide it at the back from ear to ear, then secure the hair above the part with a crocodile clip. Split the loose hair into squares and give each a single pass with the blowdryer, following the round boar-bristle brush closely from roots to ends.

3 Wrap the section around the round boar-bristle brush starting at the ends. Blast it with hot air, then gingerly unroll and roll it again as you follow the brush with the blowdryer. Once the section is dry, remove the brush and rewrap the section around two fingers, starting at the roots, to create a pin curl. Slide a silver duckbill clip into the loop's center.

4 Continue to work your hair in sections until you've dried and clipped it all up.

5 Take down the bottom row and brush it, then lightly backcomb it with a flat mixed-bristle brush, lightening up toward the ends. Take down the rows and repeat backcombing on all your sections.

6 Backcomb the hair on the top of your head up toward your crown. Create a deep side part and blast it with hairspray.

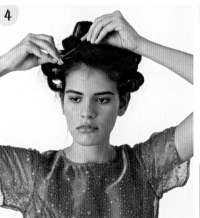

TIP
If you have bangs, sweep
them forward or to the
side, then very lightly
backcomb them so they
blend in with the rest
of your hair.

YOU'LL NEED
- Hairspray
- Flat mixed-bristle brush
- Tail comb
- 1-inch (25-mm) curling iron
- Several silver duckbill clips
- Flat boar-bristle finishing brush
- Tissue paper
- Detangling comb

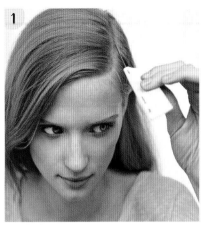

GO FOR GLAMOUR WITH
'40s Waves

You too can slink around with sexy, sultry curls—just like the old-school Hollywood vixens used to wear. Look out, Jessica Rabbit.

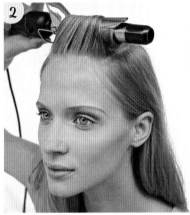

1 Liberally mist your hair with hairspray from roots to ends, working in sections to evenly distribute it throughout. Brush all your hair out with a flat mixed-bristle brush and use your tail comb to make a clean side part above your eyebrow.

2 Create a rectangular section of hair that extends from your front hairline to your crown. Divide it into smaller sections about 1 inch (25 mm) in depth. Comb the one closest to your front hairline straight up. Then use your 1-inch (25-mm) curling iron to curl it back away from your face. Get as close to the scalp as possible (without burning yourself, of course).

3 Once it's hot (which should take less than 30 seconds if you have a good iron), remove the curling iron and use a silver duckbill clip to hold the curl in place until it's cool. Repeat curling and pinning the hair in this section until you've reached your crown. Let these curls cool and set.

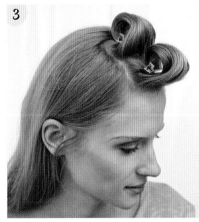

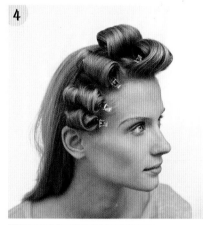

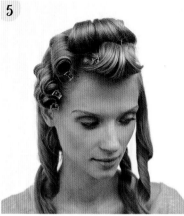

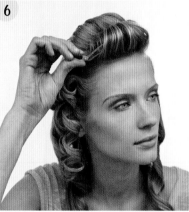

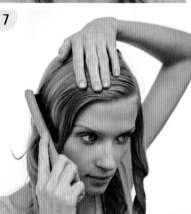

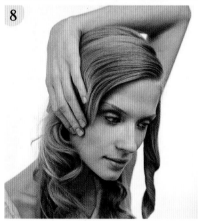

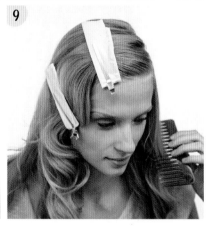

4 Move on to the hair on the side of your face, opposite your part. Curl and pin this hair so it's perpendicular to the top curls, working all the hair until you reach your ear. Let these curls set, too.

5 Divide the rest of your hair into four or five vertical sections going around your head. Curl these as well, only this time hold the iron vertically. You won't pin these in place—instead, gently tug on them after curling for a looser, wavy look.

6 Your pinned curls should be cool now. Remove the silver duckbill clips and let the curls down—they'll be little ringlets.

7 Brush the curls out with your flat boar-bristle finishing brush. Apply some pressure on your scalp with your hand as you brush, transforming the curls from ringlets to smooth waves.

8 After brushing the pin curls, put the palm of your hand over your ear and gently push the hair up toward the top of your head—you should see the waves become more defined.

9 Blast the waves with hairspray. Fold pieces of tissue paper into narrow strips and place one over the groove of each wave, then secure with silver duckbill clips and let the waves set for a few minutes. Meanwhile, go over the other curled sections with a detangling comb to make them less ringletty and more like smooth waves.

10 Spray again, take out the clips, and find a red carpet near you.

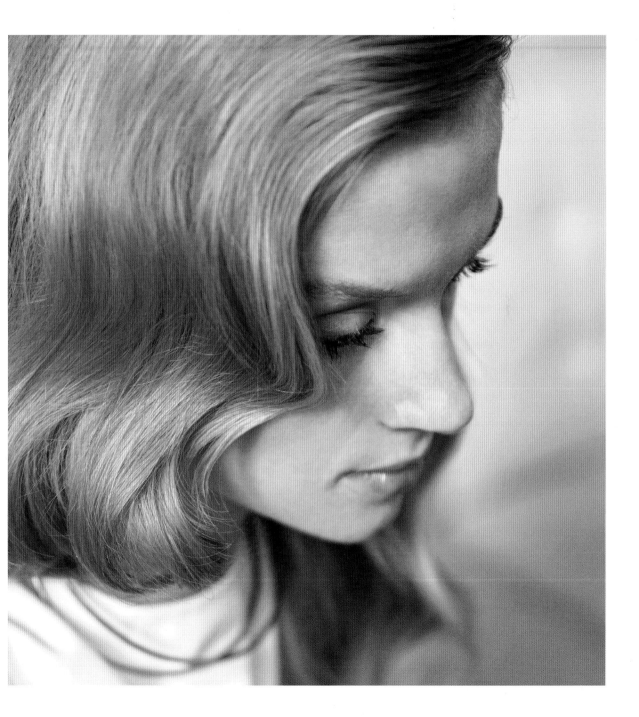

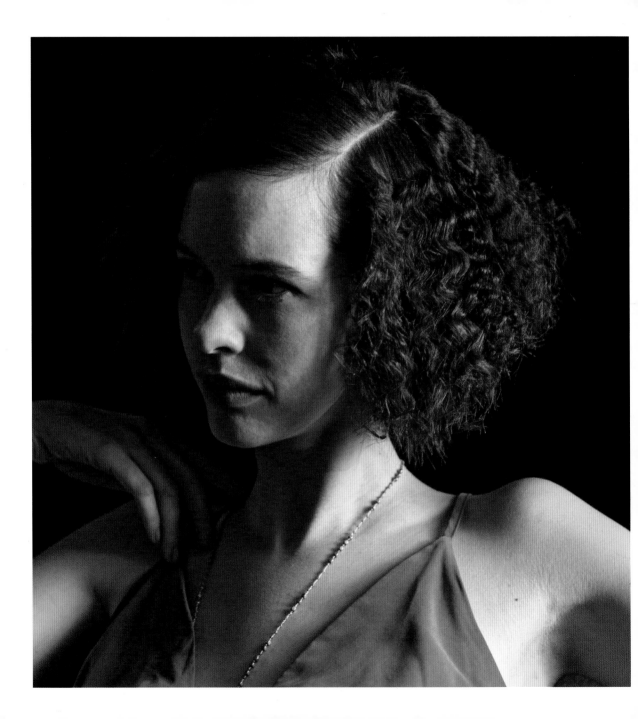

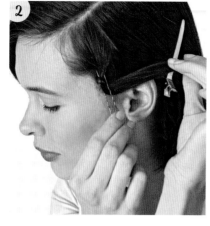

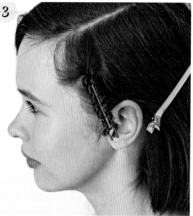

CHIC
Kinks

Leave your old crimping iron buried deep in your closet! You can get a similar zig-zag effect by wrapping sections around large hairpins. (Psst: This is great on short styles—it goes a lot quicker when you don't have a lot of locks to pin up!)

1 Start with clean, dry hair. Use your tail comb to create a clean part, then take a 1-by-1-inch (25-by-25-mm) section of hair and hairspray it from roots to ends.

2 Thread the section of hair through the U-shape end of a large hairpin, keeping the hairpin close to the scalp. Bring the hair around and under one end, through the gap, then over and around the other end, then through the gap again, weaving a figure-8 shape between the two ends.

3 Continue wrapping until you reach the ends of the section. Slide a bobby pin between the two ends of your hairpin so it locks the figure-8 shape in place.

4 Divide the rest of your hair into sections and wrap them around hairpins, then turn your flat iron to medium-high heat and clamp it around each section for a few seconds. Let all your sections cool.

5 Pull the bobby pin out of one section and remove the hairpin, then repeat until all your kinks are free! Use the end of a tail comb to separate the zig-zags.

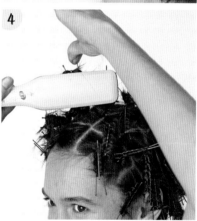

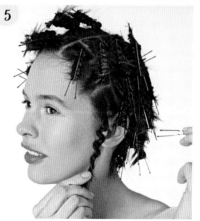

133 • CURLS

YOU'LL NEED
- Set of hot rollers (with clips)
- Blowdryer
- Root lifter or volumizing spray
- Crocodile clip
- Lightweight hairspray
- Detangling comb

OPTIONAL
- Flat mixed-bristle brush

HIGH-VOLUME
Va-Va-Voom
CURLS

Heat things up with big, bouncy, sexy curls. Go ahead, tell the world you woke up like this.

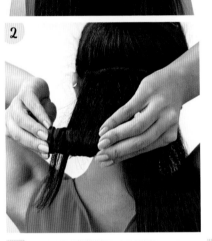

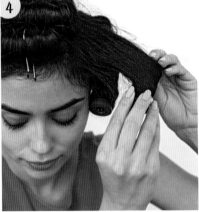

1 Plug in your rollers and, while they heat up, blow out your hair with a root lifter or volumizing product. (See page 25.) Divide a section of hair at the back of your head that spans from ear to ear. Hold the rest of your hair with a crocodile clip.

2 Gather a 1½-by-1½-inch (38-by-38-mm) section and spray it with lightweight hairspray from roots to ends to protect it from the heat and help the curl last. Holding your hair taut, wrap it around the roller starting in the middle of the section, capturing the ends to prevent flyaways. Then roll the curler up to your scalp and secure with one of the clips.

3 Keep wrapping your hair around curlers in consistently sized sections. Once all of your hair is pinned in curlers, blast them with hairspray and let them cool.

4 Take out the clips, then separate the curls with a detangling comb. To make a soft part, backcomb the hair at your front hairline, then run your fingers through it in the desired direction.

TIP

If you'd like a more loose, billowy effect than you see here, backcomb with a flat mixed-bristle brush once your curls have cooled.

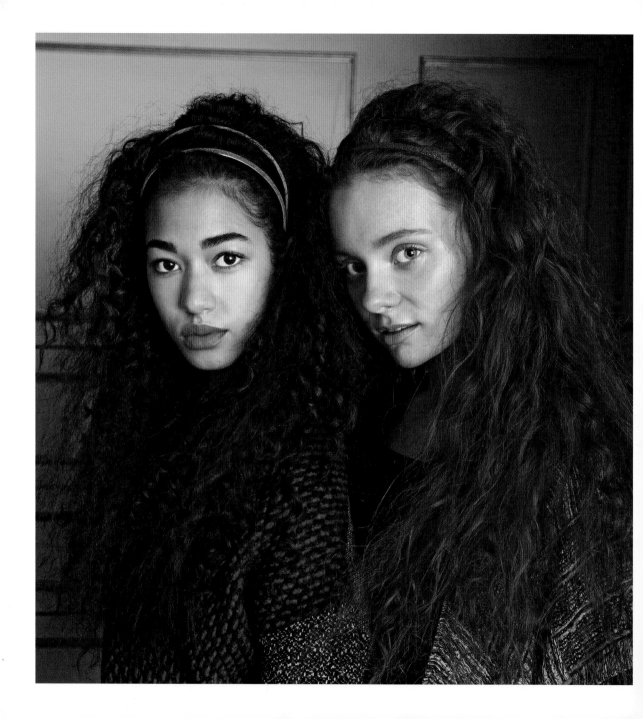

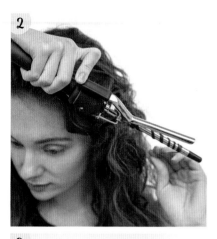

2

BOOGIE NIGHTS

Ringlets

This next look goes out to all my curly-haired friends—let's make them bigger, bolder, and more over-the-top than ever. With skinny, sparkly headbands, that disco ball's got nothing on you!

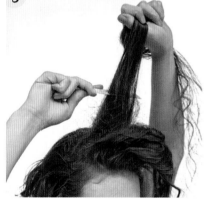

3

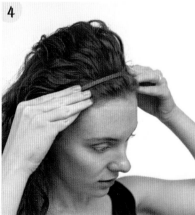

4

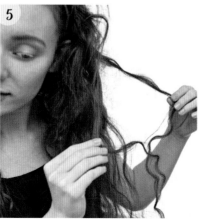

5

1 Spritz saltwater spray on damp hair and diffuse it dry while scrunching with your hands to encourage curl and texture.

2 Give your natural waves a little push with a curling iron in a size close to that of your own curls. (If you have straight hair, you can still get in on the fun: Just curl all your hair with a small curling iron and finger-brush it to create big, curly texture.) Be especially sure to curl around your hairline, framing your face with defined waves.

3 Mist hairspray all over to create a bigger curl style, and spritz texturizing spray on your curls to create volume. Then take three sections of hair at the crown of your head and backcomb them with your tail comb for height.

4 Sweep all of your hair back and use your fingers to scrunch up volume on top of your head. Slide the headbands one at a time so they're about ½ inch (12.5 mm) apart from each other.

5 Pick a few tendrils and pull them apart slightly for a wilder, party-girl vibe.

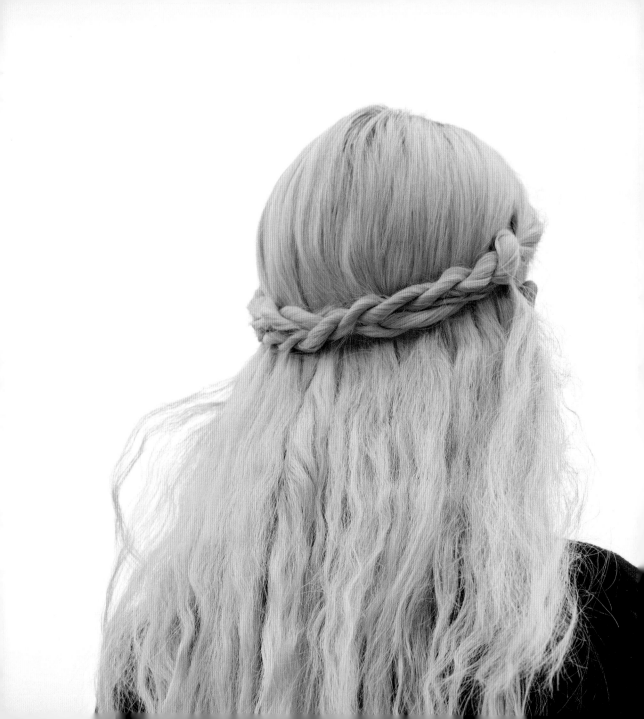

Index

weldon**owen**

President & Publisher **Roger Shaw**
SVP, Sales & Marketing **Amy Kaneko**
Finance Manager **Phil Paulick**

Senior Editor **Lucie Parker**
Editorial Assistant **Jaime Alfaro**

Creative Director **Kelly Booth**
Art Director **Alisha Petro**
Senior Production Designer
 Rachel Lopez Metzger

Production Director **Chris Hemesath**
Associate Production Director
 Michelle Duggan

1045 Sansome Street, Suite 100
San Francisco, CA 94111
www.weldonowen.com

Weldon Owen is a division of
BONNIER

Library of Congress Cataloging-in-
Publication data is available.

ISBN 13: 978-1-61628-801-3
ISBN 10: 1-61628-801-9

10 9 8 7 6 5 4 3 2 1
2015 2016 2017 2018 2019

Printed in China by 1010 Printing.

Art Credits

Photographer **Agnes Thor**
Illustrations **Samantha Jahn**
Makeup **Khela**
Wardrobe Stylist **Karen Schaupeter**

With special thanks to Andrew Musson, photography technician; Chantell Carr-Theroll and Robert Echevarria, hair assistants; Giancarlo Corrbacho and Lola Jackson, styling assistants; and Marika Aoki, KUMA, and Takahiro Okada, makeup assistants.

Thank you to our models: Anastasia Belotskaya, Emily Cross, Jandra Dziaugyte, Eileen Feighny, Destiny Kinser, Kimbra Lo, Nicolle Lobo, Hannah Kristina Metz, Enya Mommsen, Dakota Moore, Kyla Moran, Alejandra Ramos Muñoz, Karla Pereira, and Elizabeth White.

And to our talent agencies: BMG Model & Talent, Fenton Moon, Look Model Agency, MSA Models, Major Model Management, New York Model Management, and Q Management.

Additional thanks to & Other Stories, American Apparel, Family Affairs, Samatha Pleet, Erica Tanov, Upstate, and Urban Outfitters for wardrobe, plus Another Feather and Bando for jewelry and other accessories.

Further gratitude goes to Columbia Products Studio, Vandervoort Studio, and the Love Shack.

Author Acknowledgments

I'm incredibly grateful for the love and support of my husband Stanton, my parents, and my extended family. For my sisters Nadia and Vivian and best friend Angela for always letting me play with their hair. For letting me try out the looks for this book on their hair, I thank Marci, Reba, Julie, Anta, Alexandra, Nicole, and Jenna.

Thank you, Samantha Hahn, for your beautiful illustrations, and the team from our shoot. Also to my team at Weldon Owen and my literary agent Melissa Flashman. And special thanks to every hairstylist, mentor, and client who has supported my career thus far.

Publisher Acknowledgments

Weldon Owen would like to thank Kevin Broccoli, Sarah Gurman, Katharine Moore, Marisa Solís, and Kristen Spires for editorial expertise and India Sabater for design assistance.

RUBI JONES

Rubi Aguilar Jones is a New York City–based freelance hairstylist. Her styling career began at Bumble and bumble, one of the most prestigious salons in New York. In 2011, her editorial career relocated her to Paris, France. In 2014, she moved back to New York City, where she continues to style hair for magazine editorials, ad campaigns, and private clients. Rubi can be found backstage at New York and Paris Fashion Weeks each season, and in the off-season she teaches styling workshops across the United States. You can follow her work and get daily hair inspiration and tips at *www.rubijones.com*.

AGNES THOR

Swedish photographer Agnes Thor picked up a camera in her teens and graduated with a BA in Fine Arts from Gothenburg University in Sweden. She now shares her time between Stockholm and New York City, working on fine art projects and commissions in portraiture and fashion. Her work has been exhibited in Sweden, the United States, and several European countries, and published in magazines around the world.

SAMANTHA HAHN

Samantha Hahn is an award-winning illustrator working in New York City. She works with a range of clients including Marc Jacobs, Lela Rose, *NY Magazine/TheCut*, *Refinery29*, *The Paris Review* and *Vogue Nippon*. Her book *Well-Read Women: Portraits of Fictions Most Beloved Heroines* was published by Chronicle Books. Her work has been shown internationally.